DANCING IN THE WIND

Poetry and Art
of the British Isles

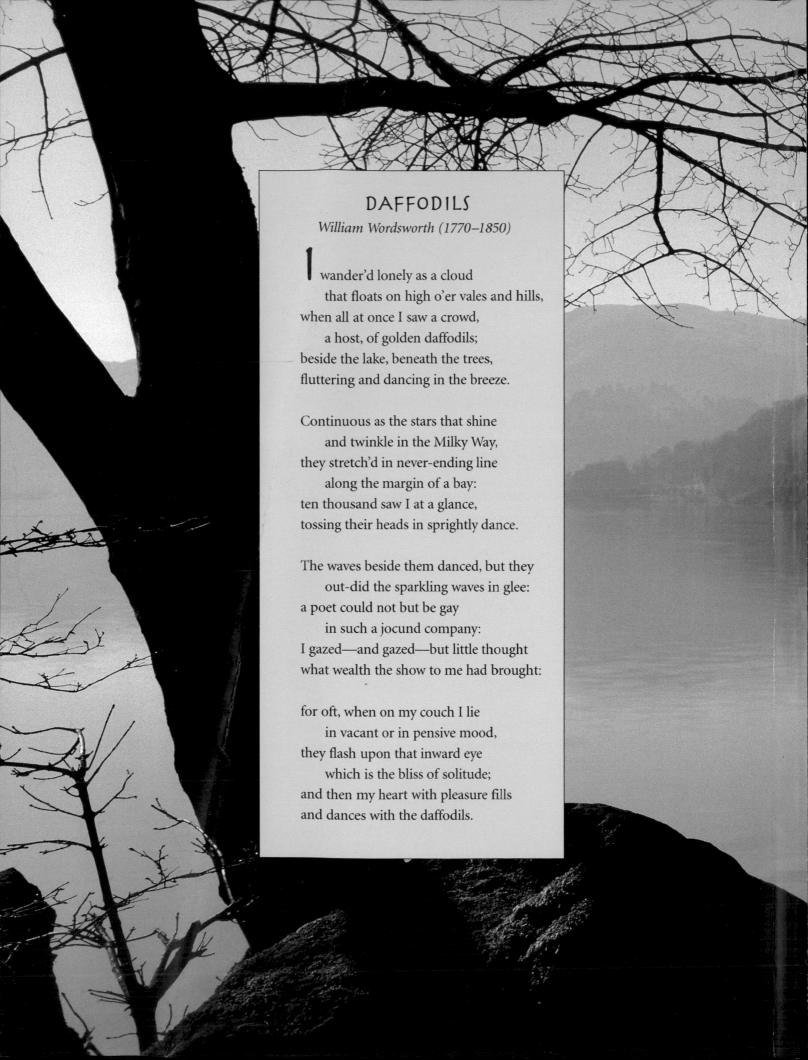

DAFFODILS
William Wordsworth (1770–1850)

I wander'd lonely as a cloud
 that floats on high o'er vales and hills,
when all at once I saw a crowd,
 a host, of golden daffodils;
beside the lake, beneath the trees,
fluttering and dancing in the breeze.

Continuous as the stars that shine
 and twinkle in the Milky Way,
they stretch'd in never-ending line
 along the margin of a bay:
ten thousand saw I at a glance,
tossing their heads in sprightly dance.

The waves beside them danced, but they
 out-did the sparkling waves in glee:
a poet could not but be gay
 in such a jocund company:
I gazed—and gazed—but little thought
what wealth the show to me had brought:

for oft, when on my couch I lie
 in vacant or in pensive mood,
they flash upon that inward eye
 which is the bliss of solitude;
and then my heart with pleasure fills
and dances with the daffodils.

CONTENTS

TO THE READER

The British Isles, which encompass Wales, Scotland, and Ireland as well as England, have produced much of the world's most colorful poetry and art. Some of these works trace a turbulent history of social conflict—invasions, wars, rebellions, strikes, uprisings—from earliest times to the present, from ancient Picts and Celts to East Indian immigrants, as various cultures have struggled against one another. Some writings and artworks deal with the basic values that bind societies together—family, home, class structure, tradition. And some are inspired by the passionate pursuit of other values and ideals, such as adventure, romance, beauty, and truth. In this book I have brought together nearly 200 examples of these colorful elements. My aim has been not to compile a comprehensive anthology of every poem that could be read, or every picture that should be looked at, but rather to make a deliberately limited selection of poetry and art, a montage of words and pictures that present the British Isles and their inhabitants from differing, at times controversial, at times contradictory, viewpoints. I hope the results of this effort will enable you to experience "the daily island life," as Gertrude Stein once described it, through glimpses of all sorts and conditions of men and women at work and at play. I hope it will also encourage you to consider some broader perspectives on the histories and interactions of the complex people who have come to be known as English, Irish, Scottish, and Welsh.

As in previous books of this kind, I have paired the works of poets and artists dealing with similar themes, for example: Shakespeare and William Blake on kingship, W. B. Yeats and Paula Rego on childhood, Carol Ann Duffy and R. B. Kitaj on being foreign, Seamus Heaney and Richard Hamilton on military power, Andrew Marvell and John Singer Sargent on lasting beauty. In addition to the work of these and other well-established figures, I have included poetry and art by some lesser-known or unknown writers and artists, because color is often to be found in unexpected places: anonymous verses, old snapshots, Dublin street ballads, nonsense rhymes, Welsh rock lyrics, graffiti—even black-and-white drawings from the London press of bygone years, even junk that most people would discard but out of which someone creates a sculpture, even a boastful speech in the House of Commons, even the hastily scribbled prayer of a Scottish queen about to lose her head. All these things and more you will find in the following pages.

To organize the book coherently I have divided its contents into three main parts, with three sections in each. The first part, "THIS ENGLAND," portrays the dominant culture of the British Isles in a fairly sympathetic way, although not every element of that portrait is affectionate or flattering. It begins with "Defense of the Realm" to celebrate the courage and resolve of island people who have defeated some invaders, absorbed others, and occasionally gone on the offensive. "Kings, Lords, and Commons" allows us to see and hear how these people have perceived one another, from top to bottom of their social hierarchies. "Coming of Age" goes through the human lifespan much as Shakespeare did in his seven stages, but mainly from the viewpoints of other individuals in various eras.

The second part, "OTHER KINGDOMS," includes Wales, Scotland, and Ireland, with a separate section for each. It is poetically licentious to call these entities "kingdoms" now, of course, for England conquered them one by one, and as of January 1, 1801, all of them were included in the "United Kingdom of Great Britain and Ireland." The Republic of Ireland won its independence later, and from time to time the remainder of the U.K. has shown signs of disunity; but politics aside, there have always been visual images worth seeing and voices worth hearing among the Irish, the Scottish, and the Welsh. Here I offer you a sampling of them.

The third part, "SHARED VALUES," illustrates several of the important similarities that underlie differences among the men and women of the British Isles. "Adventure" leads the list of shared values because so many of the inhabitants were originally newcomers in search of something important to them, while so many others have set forth to seek something important

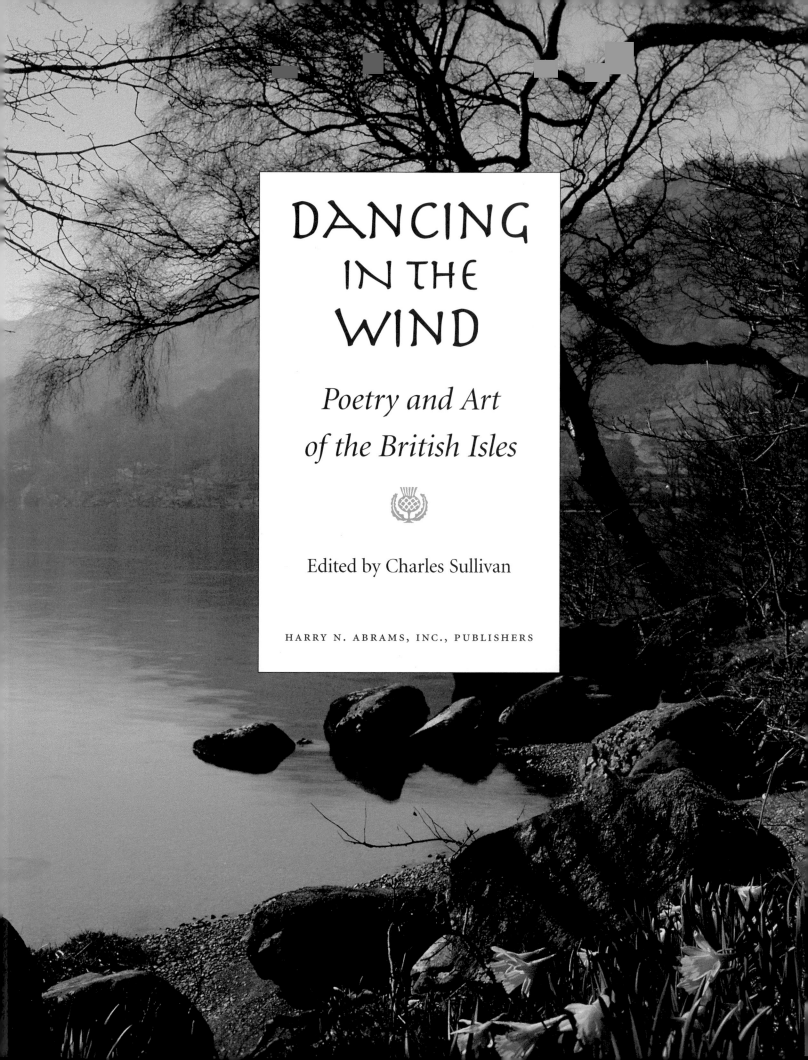

DANCING IN THE WIND

Poetry and Art
of the British Isles

Edited by Charles Sullivan

HARRY N. ABRAMS, INC., PUBLISHERS

This book is dedicated to Paul Gottlieb
my publisher, but more important,
my friend for fifty years

Editor: Nicole Columbus
Designer: Dana Sloan

Library of Congress Cataloging-in-Publication Data

Dancing in the wind : poetry and art of the British
Isles / edited by Charles Sullivan.
p. cm.
Includes bibliographical references and index.
ISBN 0–8109–0560–4
1. English poetry. 2. Great Britain—Poetry. 3. Great
Britain—In art. 4. Ireland—In art. 5. Ireland—Poetry.
6. Art, British. I. Sullivan, Charles, 1933–

PR1175 .D263 2002
821.008—dc21
2001058989

Published in 2002 by Harry N. Abrams, Incorporated, New York.
All rights reserved. No part of the contents of this book may be
reproduced without the written permission of the publisher.
Printed and bound in Italy
10 9 8 7 6 5 4 3 2 1

Harry N. Abrams, Inc.
100 Fifth Avenue
New York, N.Y. 10011
www.abramsbooks.com

Abrams is a subsidiary of

somewhere else. The section "Home-Thoughts" reflects the yearnings of generations of adventurers, soldiers, expatriates, or simply grown-up children for the warmth and security they miss. And finally, among other shared values, "Truth, Beauty" are considered especially significant by poets and artists of the several cultures making up the British Isles.

The title of this book comes from a poem by Yeats, "To a Child Dancing in the Wind," which appears on page 90. Written on the eve of World War I, with Ireland itself deeply troubled and divided, the poem describes in short, symbolic strokes the ominous forces that threaten to obliterate a child's innocence and delight in nature. I include it, along with other somber works by twentieth-century poets and artists, because the darkness they convey is a significant aspect of modern life as they have known it, including what W. H. Auden called the "Age of Anxiety." In contrast to that darkness, however, many other creative works of this and earlier periods are able to achieve a sense of lightness and brightness, reflecting optimism in spite of adversity.

A favorite example of mine is Wordsworth's "Daffodils," written in 1804, which you can find on the frontispiece of this book. Reading it now, you might assume the poet led a sheltered life amongst trees and flowers on a private estate. Actually, he lived simply and frugally in a humble cottage, remote from cities, yet well aware of the problems and forces that England faced in his day—loss of the American colonies, political spillover from the French Revolution, Napoleon's threat of invasion, among other crises. Although he wrote about such concerns in later poems, here in "Daffodils" Wordsworth is sharing with us a poet's secret of how to achieve serenity. His seeming innocence, his outspoken delight, may remind us of how children feel about nature, but I suggest the similarity is only on the surface—when Wordsworth gave voice to these feelings he was no child. Thus, we honor him today as one of those who transcend darkness by insisting on the value of what's brightest and best in this world.

I must add that Wordsworth's poem has a very special, personal importance for me. I began putting poetry and art together in thematic books during the 1980s, when I produced *America in Poetry, Imaginary Gardens, Ireland in Poetry,* and others. The basic idea, however, was given to me much earlier, in elementary school. My fourth-grade teacher read "Daffodils" aloud to us, then sent us off to draw something suggested by the poem. Other children made lots of little circles for flowers, larger ones for clouds, then colored them with crayons. I went across the street to a neighbor's garden, Mrs. Ward's, and really looked at some daffodils as though I had never seen flowers before. Then I drew several of them as well as I could, close up, with their distinctive petals and dark, curving leaves. To me they seemed to dance. Or perhaps my hand was not quite steady. In any case, my childish picture is long gone, but the memory of it is still fresh for me, like Wordsworth's poetry, and the association of visual images with verbal images has become second nature.

Among others who have encouraged and facilitated my work on this latest book, again I thank Paul Gottlieb, to whom it is dedicated, and the able people he assembled at Harry N. Abrams, Inc., including Nikki Columbus, Dana Sloan, Jonathan Stolper, and John Crowley. Of all the museums and galleries I visited, the Tate Britain and Tate Modern are especially memorable for their thematic emphasis and for the balance they achieve between interpretation and experience, thanks to the leadership of Sir Nicholas Serota. Among his staff, Celia Clear and Christopher Webster of Tate Publications have been incomparably helpful. Special thanks to the Victoria & Albert Museum, the Wordsworth Trust, Acquavella Contemporary Art, Inc., New York, Kraushaar Galleries, New York, and The Prints and Photographs Division, Library of Congress, for making other resources available. Any number of dedicated archivists, librarians, booksellers, and Website designers, particularly those at the Tate, are also deserving of appreciation for making this project easier and more pleasant.

Charles Sullivan
San Francisco, California
and La Roque, France

THIS ENGLAND: DEFENSE OF THE REALM

I THINK CONTINUALLY OF THOSE WHO WERE TRULY GREAT

Sir Stephen Spender (1909–1995)

I think continually of those who were truly great.
Who, from the womb, remembered the soul's history
Through corridors of light where the hours are suns
Endless and singing. Whose lovely ambition
Was that their lips, still touched with fire,
Should tell of the Spirit clothed from head to foot in song.
And who hoarded from the Spring branches
The desires falling across their bodies like blossoms.

What is precious is never to forget
The essential delight of the blood drawn from ageless springs
Breaking through rocks in worlds before our earth.
Never to deny its pleasure in the morning simple light
Nor its grave evening demand for love.
Never to allow gradually the traffic to smother
With noise and fog the flowering of the spirit.

Near the snow, near the sun, in the highest fields
See how these names are fêted by the waving grass
And by the streamers of white cloud
And whispers of wind in the listening sky.
The names of those who in their lives fought for life,
Who wore at their hearts the fire's centre.
Born of the sun they travelled a short while towards the sun,
And left the vivid air signed with their honour.

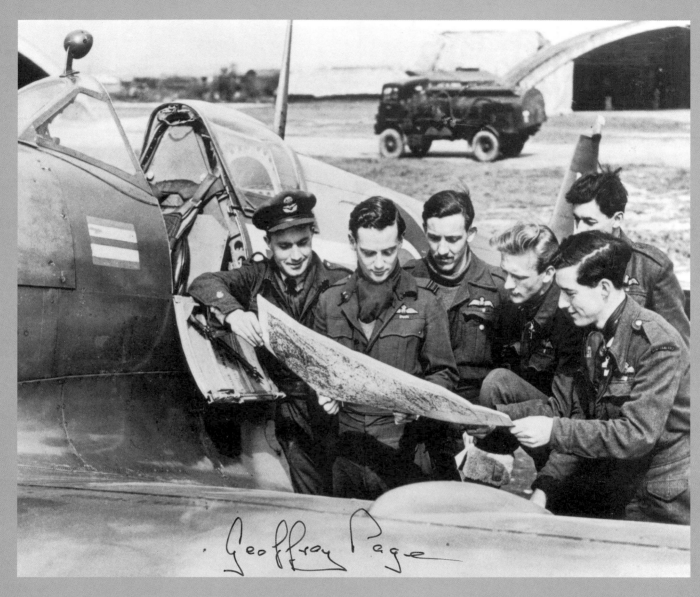

Geoffrey Page

R.A.F. FIGHTER PILOTS PREPARING
FOR ACTION AGAINST THE GERMAN
LUFTWAFFE DURING THE BATTLE OF
BRITAIN, AUGUST 6–SEPTEMBER 15, 1940
(Photographer unknown)

Gallant young fliers such as these saved
England from invasion. Churchill said
of them, "Never in the field of human
conflict was so much owed by so many
to so few."

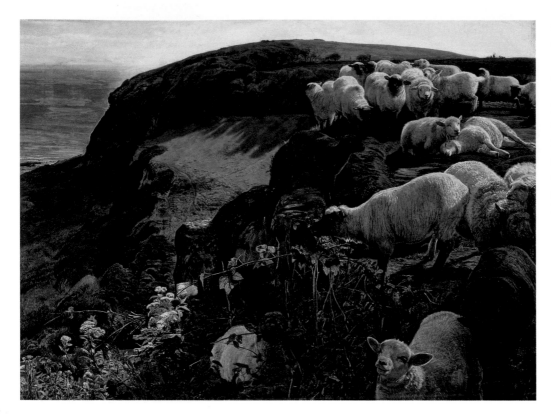

OUR ENGLISH COASTS
("STRAYED SHEEP")
William Holman Hunt
(1827–1910)

Painted near Hastings, where
the Normans landed in 1066,
this picture was considered a
satire on Britain's defenseless
condition at a time when
another invasion from
France seemed possible.

THIS SCEPTER'D ISLE

(from *The Tragedy of King Richard II*, Act II, Scene 1)

William Shakespeare (1564–1616)

This royal throne of kings, this scepter'd isle,
This earth of Majesty, this seat of Mars,
This other Eden, demi-paradise,
This fortress built by Nature for herself
Against infection and the hand of war,
This happy breed of men, this little world,
This precious stone set in the silver sea,
Which serves it in the office of a wall,
Or as a moat defensive to a house,
Against the envy of less happier lands,
This blessed plot, this earth, this realm, this England,
This nurse, this teeming womb of royal kings,
Fear'd by their breed and famous by their birth,
Renowned for their deeds as far from home,
For Christian service and true chivalry,

As is the sepulchre in stubborn Jewry
Of the world's ransom, blessed Mary's Son;
This land of such dear souls, this dear dear land,
Dear for her reputation through the world,
Is now leas'd out, I die pronouncing it,
Like to a tenement or pelting farm:
England, bound in with the triumphant sea,
Whose rocky shore beats back the envious siege
Of wat'ry Neptune, is now bound in with shame,
With inky blots and rotten parchment bonds:
That England, that was wont to conquer others,
Hath made a shameful conquest of itself.
Ah, would the scandal vanish with my life,
How happy then were my ensuing death!

DOVER BEACH

Matthew Arnold (1822–1888)

The sea is calm to-night.
The tide is full, the moon lies fair
upon the straits;—on the French coast the light
gleams and is gone; the cliffs of England stand
glimmering and vast, out in the tranquil bay.
Come to the window, sweet is the night-air!
Only, from the long line of spray
where the sea meets the moon-blanch'd land,
listen! you hear the grating roar
of pebbles which the waves draw back, and fling,
at their return, up the high strand,
begin, and cease, and then again begin,
with tremulous cadence slow, and bring
the eternal note of sadness in.

Sophocles long ago
heard it on the Aegean, and it brought
into his mind the turbid ebb and flow
of human misery; we
find also in the sound a thought,
hearing it by this distant northern sea.

The Sea of Faith
was once, too, at the full, and round earth's shore
lay like the folds of a bright girdle furl'd.
But now I only hear
its melancholy, long, withdrawing roar,
retreating, to the breath
of the night-wind, down the vast edges drear
and naked shingles of the world.

Ah, love, let us be true
to one another! for the world, which seems
to lie before us like a land of dreams,
so various, so beautiful, so new,
hath really neither joy, nor love, nor light,
nor certitude, nor peace, nor help for pain;
and we are here as on a darkling plain
swept with confused alarms of struggle and flight,
where ignorant armies clash by night.

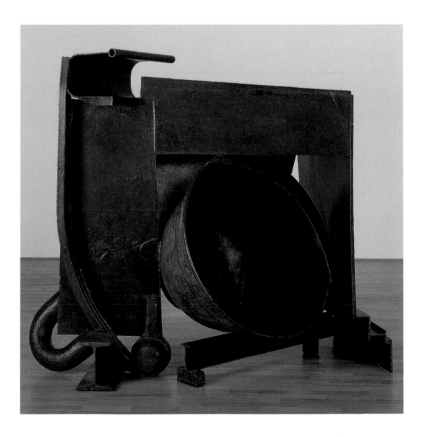

THE SOLDIER'S TALE
Sir Anthony Caro (b. 1924)

The title of this sculpture refers
to a musical composition by
Igor Stravinsky, in which dis-
parate elements are made to
form an artistic whole.

FRENCH REVOLUTION

AS IT APPEARED TO ENTHUSIASTS AT ITS COMMENCEMENT

William Wordsworth (1770–1850)

Oh! pleasant exercise of hope and joy!
for mighty were the auxiliars which then stood
upon our side, we who were strong in love!
Bliss it was in that dawn to be alive,
but to be young was very heaven!—Oh! times,
in which the meagre, stale, forbidding ways
of custom, law, and statute, took at once
the attraction of a country in romance!
when Reason seemed the most to assert her rights,
when most intent on making of herself
a prime Enchantress—to assist the work
which then was going forward in her name!
Not favored spots alone, but the whole earth,
the beauty wore of promise, that which sets
(as at some moment might not be unfelt
among the bowers of paradise itself)
the budding rose above the rose full blown.
What temper at the prospect did not wake
to happiness unthought of? The inert
were roused, and lively natures rapt away!

They who had fed their childhood upon dreams,
the playfellows of fancy, who had made
all powers of swiftness, subtilty, and strength
their ministers,—who in lordly wise had stirred
among the grandest objects of the sense,
and dealt with whatsoever they found there
as if they within some lurking right
to wield it;—they, too, who, of gentle mood,
had watched all gentle motions, and to these
had fitted their own thoughts, schemers more mild,
and in the region of their peaceful selves;—
now was it that both found, the meek and lofty
did both find, helpers to their heart's desire,
and stuff at hand, plastic as they could wish;
were called upon to exercise their skill,
not in Utopia, subterranean fields,
or some secreted island, Heaven knows where!
but in the very world, which is the world
of all of us,—the place where in the end
we find our happiness, or not at all!

BABY, BABY

Anonymous (c. 1800)

Baby, baby, naughty baby,
hush, you squalling thing, I say.
Peace this moment, peace, or maybe
Bonaparte will pass this way.

Baby, baby, he's a giant,
tall and black as Rouen steeple,
and he breakfasts, dines, rely on't,
every day on naughty people.

Baby, baby, if he hears you,
as he gallops past the house,
limb from limb at once he'll tear you,
just as pussy tears a mouse.

THE REVOLUTIONARY FRENCH
REPUBLIC DEPICTED AS A "GREAT
MONSTER" THREATENING BRITAIN.
(Artist unknown)

Despite their traditional love of
political freedom, the British had
little use for France's version of
"Liberty, Equality, Fraternity." After
some initial setbacks, Britain rallied
the monarchies of Europe to defeat
Napoleon's army in 1815.

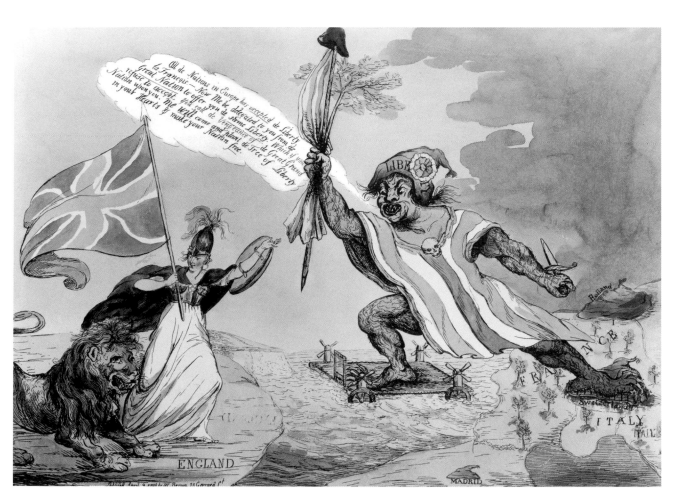

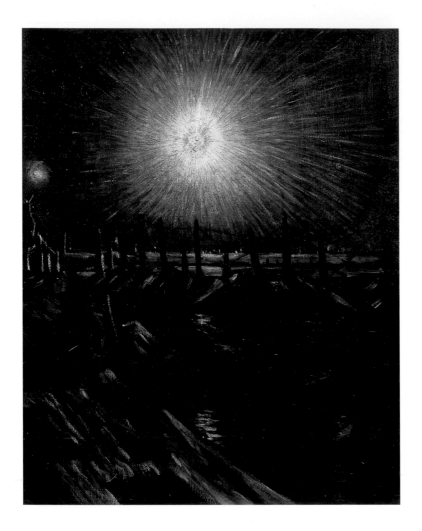

A STAR SHELL
*Christopher Richard Wynne
Nevinson (1889–1946)*

After serving as a medical worker
on the Western Front during World
War I, Nevinson depicted injury
and death so vividly that some of
his paintings were censored.

THE SOLDIER

Rupert Brooke (1887–1915)

If I should die, think only this of me:
 that there's some corner of a foreign field
that is for ever England. There shall be
 in that rich earth a richer dust conceal'd:
a dust whom England bore, shaped, made aware,
 gave, once, her flowers to love, her ways to roam,
a body of England's, breathing English air,
 wash'd by the rivers, blest by suns of home.
And think, this heart, all evil shed away,
 a pulse in the eternal mind, no less
 gives somewhere back the thoughts by England given;
her sights and sounds; dreams happy as her day;
 and laughter, learnt of friends; and gentleness,
 in hearts at peace, under an English heaven.

IN FLANDERS FIELDS

John McCrae (1872–1918)

In Flanders fields the poppies blow
Between the crosses, row on row,
 That mark our place; and in the sky
 The larks, still bravely singing, fly
Scarce heard amid the guns below.

We are the Dead. Short days ago
We lived, felt dawn, saw sunset glow,
 Loved and were loved, and now we lie
 In Flanders fields.

Take up our quarrel with the foe:
To you from failing hands we throw
 The torch; be yours to hold it high.
 If ye break faith with us who die
We shall not sleep, though poppies grow
 In Flanders fields.

FROM MY DIARY, JULY 1914

Wilfred Owen (1893–1918)

L eaves
 Murmuring by myriads in the shimmering trees.
Lives
 Wakening with wonder in the Pyrenees.
Birds
 Cheerily chirping in the early day.
Bards
 Singing of summer, scything thro' the hay.
Bees
 Shaking the heavy dews from bloom and frond.
Boys
 Bursting the surface of the ebony pond.
Flashes
 Of swimmers carving thro' the sparkling cold.
Fleshes
 Gleaming with wetness to the morning gold.
A mead
 Bordered about with warbling water brooks.
A maid
 Laughing the love-laugh with me; proud of looks.
The heat
 Throbbing between the upland and the peak.
Her heart
 Quivering with passion to my pressed cheek.
Braiding
 Of floating flames across the mountain brow.
Brooding
 Of stillness; and a sighing of the bough.
Stirs
 Of leaflets in the gloom; soft petal-showers;
Stars
 Expanding with the starr'd nocturnal flowers.

THE GREAT LONDON FIRE

(from *Annus Mirabilis*)

John Dryden (1631–1700)

A key of fire ran all along the shore,
And lightened all the river with a blaze;
The wakened tides began again to roar,
And wondering fish in shining waters gaze.

Old Father Thames raised up his reverend head,
But feared the fate of Simois would return;
Deep in his ooze he sought his sedgy bed,
And shrunk his waters back into his urn.

The Fire meantime walks in a broader gross;
To either hand his wings he opens wide;
He wades the streets, and straight he reaches cross,
And plays his longing flames on th' other side.

To every nobler portion of the town
The curling billows roll their restless tide;
In parties now they straggle up and down,
As armies unopposed for prey divide.

THE GREAT FIRE OF LONDON, 1666
(Artist unknown)

In the ashes of this catastrophic fire, the
cause of which is still unclear, London
was gradually reborn—bigger, and many
say better, than ever.

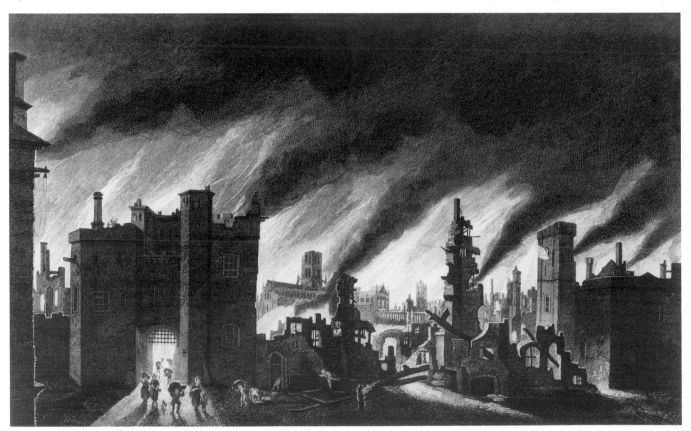

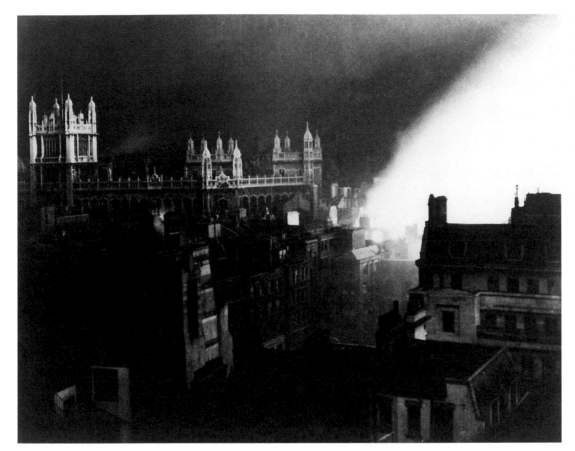

A REFUSAL TO MOURN THE DEATH, BY FIRE, OF A CHILD IN LONDON

Dylan Thomas (1914–1953)

Never until the mankind making
Bird beast and flower
Fathering and all humbling darkness
Tells with silence the last light breaking
And the still hour
Is come of the sea tumbling in harness

And I must enter again the round
Zion of the water bead
And the synagogue of the ear of corn
Shall I let pray the shadow of a sound
Or sow my salt seed
In the least valley of sackcloth to mourn

The majesty and burning of the child's death.
I shall not murder
The mankind of her going with a grave truth
Nor blaspheme down the stations of the breath
With any further
Elegy of innocence and youth.

Deep with the first dead lies London's daughter,
Robed in the long friends,
The grains beyond age, the dark veins of her mother,
Secret by the unmourning water
Of the riding Thames.
After the first death, there is no other.

Lee-Enfield
No. 1, Mk. III Rifle

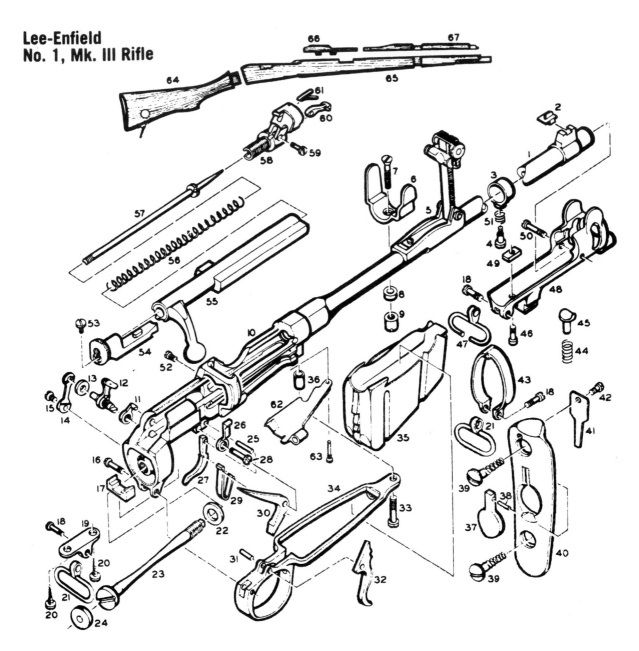

1	Barrel	**24**	Stock Bolt Wad (Leather)	**46**	Rear Nose Cap Screw	
2	Front Sight Blade	**25**	Magazine Catch Pin	**47**	Stocking Swivel	
3	Inner Band	**26**	Retaining Spring	**48**	Nose Cap	
4	Inner Band Screw	**27**	Magazine Catch	**49**	Nose Cap Nut	
5	Rear Sight Assembly	**28**	Retaining Spring Screw	**50**	Front Nose Cap Screw	
6	Rear Sight Protector	**29**	Sear Spring	**51**	Inner Band Screw Spring	
7	Rear Sight Protector Screw	**30**	Sear	**52**	Ejector Screw	
8	Fore-end Collar	**31**	Trigger Pin	**53**	Striker Screw	
9	Protector Nut	**32**	Trigger	**54**	Cocking Piece	
10	Receiver	**33**	Front Trigger Guard Screw	**55**	Breech Bolt	
11	Safety Catch	**34**	Trigger Guard	**56**	Mainspring	
12	Locking Bolt	**35**	Magazine	**57**	Striker	
13	Safety Catch Washer	**36**	Front Trigger Guard Screw	**58**	Breech Bolt Head	
14	Safety Spring	**37**	Buttplate Trap	**59**	Extractor Screw	
15	Safety Spring Screw	**38**	Buttplate Trap Pin	**60**	Extractor	
16	Rear Trigger Guard Screw	**39**	Buttplate Screw	**61**	Extractor Spring	
17	Stock Bolt Plate	**40**	Buttplate	**62**	Magazine Cut-Off	
18	Swivel Screw	**41**	Buttplate Trap Spring	**63**	Cut-Off Screw	
19	Butt Swivel Bracket	**42**	Buttplate Trap Spring Screw	**64**	Buttstock	
20	Swivel Bracket Screw	**43**	Outer Band	**65**	Fore-end	
21	Sling Swivel	**44**	Fore-End Stud Spring	**66**	Rear Hand Guard	
22	Stock Bolt Washer	**45**	Fore-end Stud	**67**	Front Hand Guard	
23	Stock Bolt					

NAMING OF PARTS

Henry Reed (1914–1986)

Today we have naming of parts. Yesterday,
We had daily cleaning. And tomorrow morning,
We shall have what to do after firing. But today,
Today we have naming of parts. Japonica
Glistens like coral in all of the neighbouring gardens,
 And today we have naming of parts.

This is the lower sling swivel. And this
Is the upper sling swivel, whose use you will see of,
When you are given your slings. And this is the piling swivel,
Which in your case you have not got. The branches
Hold in the gardens, their silent, eloquent gestures,
 Which in our case we have not got.

This is the safety-catch, which is always released
With an easy flick of the thumb. And please do not let me
See anyone using his finger. You can do it quite easy
If you have any strength in your thumb. The blossoms
Are fragile and motionless, never letting anyone see
 Any of them using their finger.

And this you can see is the bolt. The purpose of this
Is to open the breech, as you see. We can slide it
Rapidly backwards and forwards: we call this
Easing the spring. And rapidly backwards and forwards
The early bees are assaulting and fumbling the flowers:
 They call it easing the Spring.

They call it easing the Spring: it is perfectly easy
If you have any strength in your thumb: Like the bolt,
And the breech, and the cocking-piece, and the point of balance,
Which in our case we have not got, and the almond-blossom
Silent in all of the gardens, the bees going backwards and forwards,
 For today we have naming of parts.

EXPLODED DIAGRAM OF A LEE-
ENFIELD RIFLE *(Published in
Gun Digest)*

Reed was probably trained with
a weapon similar to this in the
British army during World War II.

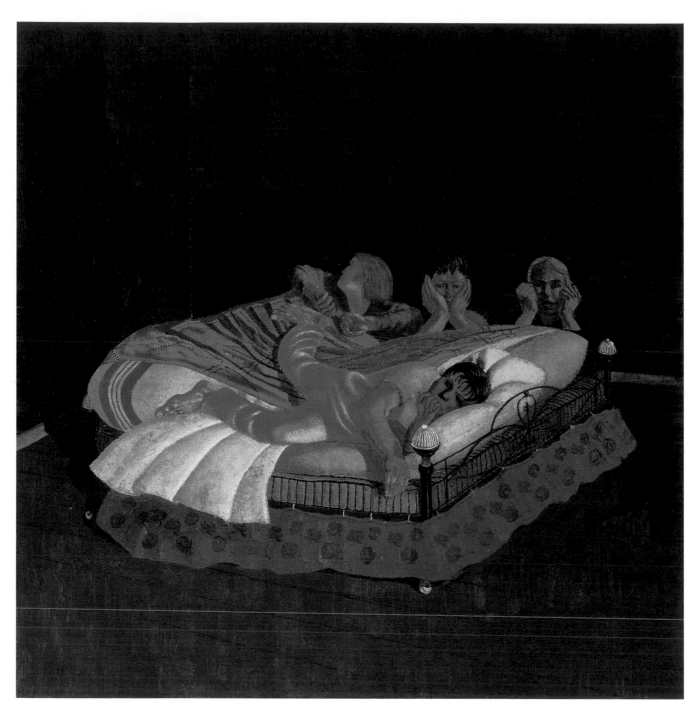

THE CENTURION'S SERVANT
Sir Stanley Spencer (1891–1959)

The title of this painting refers to a Biblical
story in which Jesus, after marveling at the
faith of a Roman centurion, heals his sick
servant without entering the house.

JERUSALEM

(from *Milton*)

William Blake (1757–1827)

And did those feet in ancient time
 walk upon England's mountains green?
And was the holy Lamb of God
 on England's pleasant pastures seen?

And did the Countenance Divine
 shine forth upon our clouded hills?
And was Jerusalem builded here
 among these dark Satanic Mills?

Bring me my bow of burning gold!
 Bring me my arrows of desire!
Bring me my spear! O clouds, unfold!
 Bring me my chariot of fire!

I will not cease from mental fight,
 nor shall my sword sleep in my hand,
till we have built Jerusalem
 in England's green and pleasant land.

IF THIS WERE FAITH

Robert Louis Stevenson (1850–1894)

God, if this were enough,
That I see things bare to the buff
And up to the buttocks in mire;
That I ask not hope nor hire,

Nut in the husk,
Nor dawn beyond the dusk,
Nor life beyond death:
God, if this were faith?

Having felt thy wind in my face
Spit sorrow and disgrace,
Having seen thine evil doom
In Golgotha and Khartoum,
And the brutes, the work of thine hands,
Fill with injustice lands
And stain with blood the sea:
If still in my veins the glee
Of the black night and the sun
And the lost battle, run:
If, an adept,
The iniquitous lists I still accept
With joy, and joy to endure and be withstood,
And still to battle and perish for a dream of good:
God, if that were enough?

If to feel, in the ink of the slough,
And the sink of the mire,
Veins of glory and fire
Run through and transpierce and transpire,
And a secret purpose of glory in every part,
And the answering glory of battle fill my heart;
To thrill with the joy of girded men
To go on for ever and fail and go on again,
And be mauled to the earth and arise,
And contend for the shade of a word and a thing not
 seen with the eyes:
With the half of a broken hope for a pillow at night
That somehow the right is the right
And the smooth shall bloom from the rough:
Lord, if that were enough?

ONCE MORE UNTO THE BREACH

(from *The Life of King Henry V*, Act III, Scene 1)

William Shakespeare (1564–1616)

(Enter the King, accompanied by the Dukes of Exeter, Bedford, and Gloucester. Alarum, with Soldiers carrying scaling ladders.)

KING HENRY:

Once more unto the breach, dear friends, once more;
or close the wall up with our English dead.
In peace there's nothing so becomes a man
as modest stillness and humility:
but when the blast of war blows in our ears,
then imitate the action of the tiger;
stiffen the sinews, summon up the blood,
disguise fair nature with hard-favour'd rage;
then lend the eye a terrible aspect;
let it pry through the portage of the head
like the brass cannon; let the brow o'erwhelm it
as fearfully as doth a galled rock
o'erhang and jutty his confounded base,
swill'd with the wild and wasteful ocean.
Now set the teeth and stretch the nostril wide,
hold hard the breath and bend up every spirit
to his full height. On, on, you noblest English,
whose blood is fet from fathers of war-proof!
Fathers that, like so many Alexanders,
have in these parts from morn till even fought
and sheath'd their swords for lack of argument:
dishonour not your mothers; now attest
that those whom you call'd fathers did beget you.
Be copy now to men of grosser blood,
and teach them how to war. And you, good yeomen,
whose limbs were made in England, show us here
the mettle of your pasture; let us swear
that you are worth your breeding; which I doubt not;
for there is none of you so mean and base,
that hath not noble lustre in your eyes.
I see you stand like greyhounds in the slips,
straining upon the start. The game's afoot:
follow your spirit, and upon this charge
cry 'God for Harry, England, and Saint George!'

CHURCHILL IN A "CHURCHILL," SEPTEMBER 20, 1942—the Prime Minister using communications equipment in one of the new British tanks named after him. *(Photographer unknown)*

"The Churchill is heavy enough to be used as a pillbox if need be," according to an official press release, "but its thunderous 6-pounders give it tremendous fire-power."

FROM A SPEECH IN THE HOUSE OF COMMONS, JUNE 4, 1940

Sir Winston Churchill (1874–1965)

We shall defend our island
whatever the cost may be.
We shall fight on the beaches,
we shall fight on the landing grounds,
we shall fight in the fields and the streets,
we shall fight in the hills;
we shall never surrender.

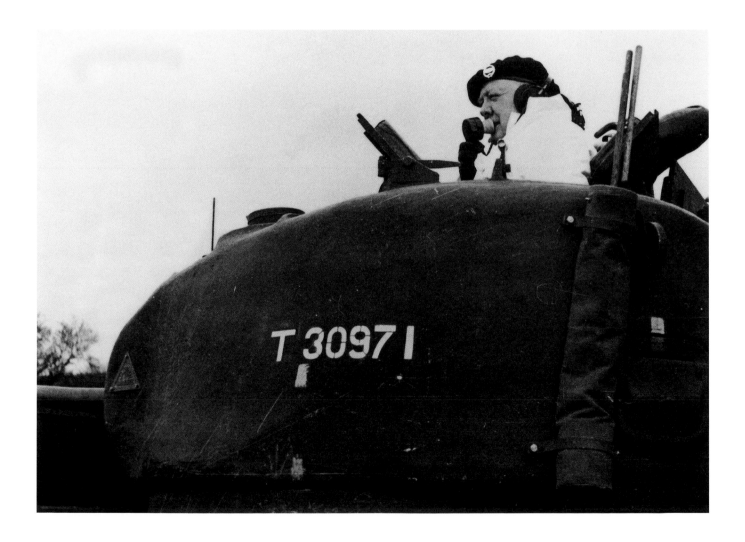

THIS ENGLAND: KINGS, LORDS, AND COMMONS

FOR A' THAT

Shirley Brooks (1816–1874)

More luck to honest poverty,
 It claims respect, and a' that;
But honest wealth's a better thing,
 We dare be rich for a' that.
 For a' that, and a' that,
 And spooney cant and a' that,
 A man may have a ten-pun note,
 And be a brick for a' that.

What though on soup and fish we dine,
 Wearing evening togs and a' that,
A man may like good meat and wine,
 Nor be a knave for a' that.
 For a' that, and a' that,
 Their fustian talk and a' that,
 A gentleman, however clean,
 May have a heart for a' that. . . .

A prince can make a belted knight,
 A marquis, duke, and a' that,
And if the title's earned all right,
 Old England's fond of a' that.
 For a' that, and a' that,
 Beales' balderdash, and a' that,
 A name that tells of service done
 Is worth the wear, for a' that.

Then let us pray that come it may
 And come it will for a' that,
That common sense may take the place
 Of common cant and a' that.
 For a' that, and a' that,
 Who cackles trash and a' that,
 Or be he lord, or be he low,
 The man's an ass for a' that.

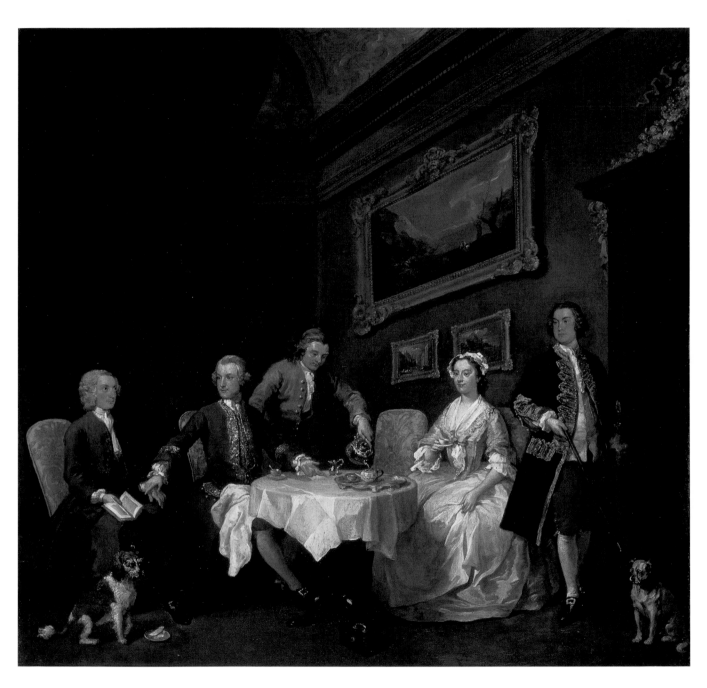

THE STRODE FAMILY
William Hogarth (1697–1764)

William Strode and his wife, Lady Anne
Cecil, entertain his former tutor, Dr.
Arthur Smyth, later Archbishop of Dublin.

COME HITHER, LADS, AND HARKEN

(from "The Day Is Coming")

William Morris (1834–1896)

Come hither, lads, and harken, for a tale there is to tell,
of the wonderful days a-coming, when all shall be better than well.

And the tale shall be told of a country, a land in the midst of the sea,
and folks shall call it England in the days that are going to be.

There more than one in a thousand in the days that are yet to come,
shall have some hope of the morrow, some joy of the ancient home.

For then, laugh not, but listen to this strange tale of mine,
all folks that are in England shall be better lodged than swine.

Then a man shall work and bethink him, and rejoice in the deeds of his hand,
nor yet come home in the even too faint and weary to stand.

Men in that time a-coming shall work and have no fear
for to-morrow's lack of earning and the hunger-wolf anear.

I tell you this for a wonder, that no man then shall be glad
of his fellow's fall and mishap to snatch at the work he had.

For that which the worker winneth shall then be his indeed,
nor shall half be reaped for nothing by him that sowed no seed.

O strange new wonderful justice! But for whom shall we gather the gain?
For ourselves and each of our fellows, and no hand shall labour in vain.

Then all Mine and all Thine shall be Ours, and no more shall any man crave
for riches that serve for nothing but to fetter a friend for a slave. . . .

MORRIS READING POETRY
TO BURNE-JONES
Sir Edward Coley Burne-Jones, Bt
(1833–1898)

This informal sketch, which
may or may not have been
meant for Morris to see, should
be amusing to earnest poets and
their long-suffering friends.

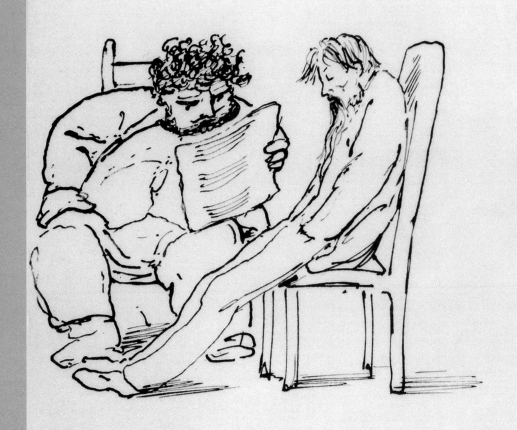

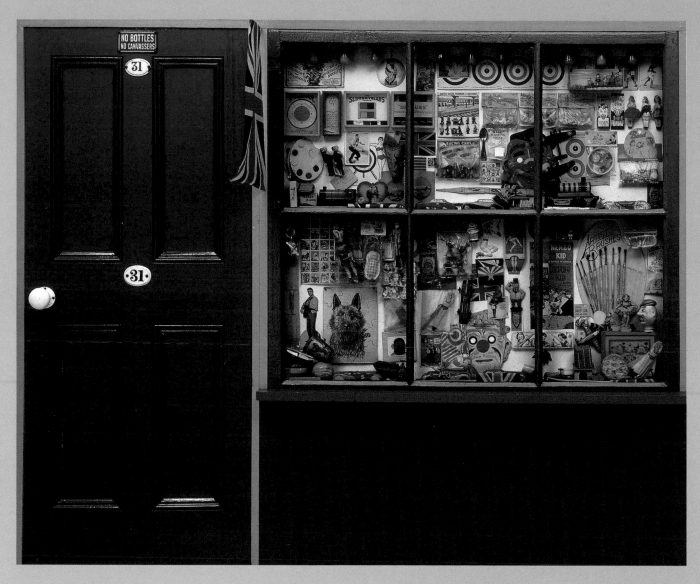

THE TOY SHOP
Peter Blake (b. 1932)

Blake took the door and window
from a demolition site to create this
work, which also served as a way of
storing his collection of toys.

ADVICE TO A SHOP-KEEPER

(Stanzas III, V, IX, XIV, XX–XXII from "Shop")

Robert Browning (1812–1889)

I thought "And he who owns the wealth
 Which blocks the window's vastitude,
—Ah, could I peep at him by stealth
 Behind his ware, pass shop, intrude
 On house itself, what scenes were viewed!

"Pictures he likes, or books perhaps;
 And as for buying most and best,
Commend me to these City chaps!
 Or else he's social, takes his rest
 On Sundays, with a Lord for guest."

Nowise! At back of all that spread
 Of merchandize, woe's me, I find
A hole i' the wall where, heels by head,
 The owner couched, his ware behind.
 —In cupboard suited to his mind.

Shop was shop only: household-stuff?
 What did he want with comforts there?
"Walls, ceiling, floor, stay blank and rough,
 So goods on sale show rich and rare!
 'Sell and scud home' be shop's affair!"

Because a man has shop to mind
 In time and place, since flesh must live,
Need spirit lack all life behind,
 All stray thoughts, fancies fugitive,
 All loves except what trade can give?

I want to know a butcher paints,
 A baker rhymes for his pursuit,
Candlestick-maker much acquaints
 His soul with song, or, haply mute,
 Blows out his brains upon the flute!

But—shop each day and all day long!
 Friend, your good angel slept, your star
Suffered eclipse, fate did you wrong!
 From where these sorts of treasures are,
 There should our hearts be—Christ, how far!

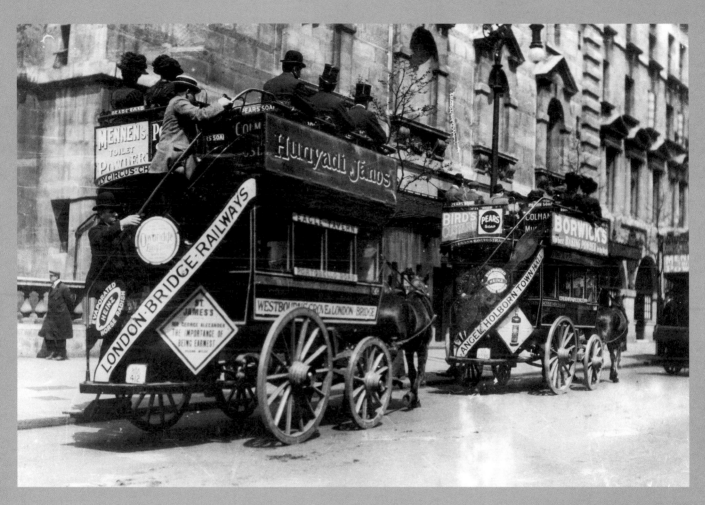

LONDON STREET SCENE, 19TH
CENTURY (*Photographer unknown*)

The world capital of commerce for
many years, London could tell its
own story in advertisements and
photographs such as this one.

LONDON

John Davidson (1857–1909)

Athwart the sky a lonely sigh
 From west to east the sweet wind carried;
The sun stood still on Primrose Hill;
 His light in all the city tarried:
The clouds on viewless columns bloomed
Like smouldering lilies unconsumed.

'Oh sweetheart, see! how shadowy,
 Of some occult magician's rearing,
Or swung in space of heaven's grace
 Dissolving, dimly reappearing,
Afloat upon ethereal tides
St Paul's above the city rides.'

A rumour broke through the thin smoke
 Enwreathing abbey, tower, and palace,
The parks, the squares, the thoroughfares,
 The million-peopled lanes and alleys,
An ever-muttering prisoned storm,
The heart of London breathing warm.

THE MOTOR BUS

A. D. Godley (1856–1925)

What is this that roareth thus?
Can it be a Motor Bus?
Yes, the smell and hideous hum
Indicant Motorem Bum!
Implet in the Corn and High
Terror me Motoris Bi:
Bo Motori clamitabo
Ne Motore caedar a Bo—
Dative be or Ablative
So thou only let us live:—
Whither shall thy victims flee?
Spare us, spare us, Motor Be!
Thus I sang, and still anigh
Came in hordes Motores Bi,
Et complebat omne forum
Copia Motorum Borum.
How shall wretches live like us
Cincti Bis Motoribus?
Domine, defende nos
Contra hos Motores Bos!

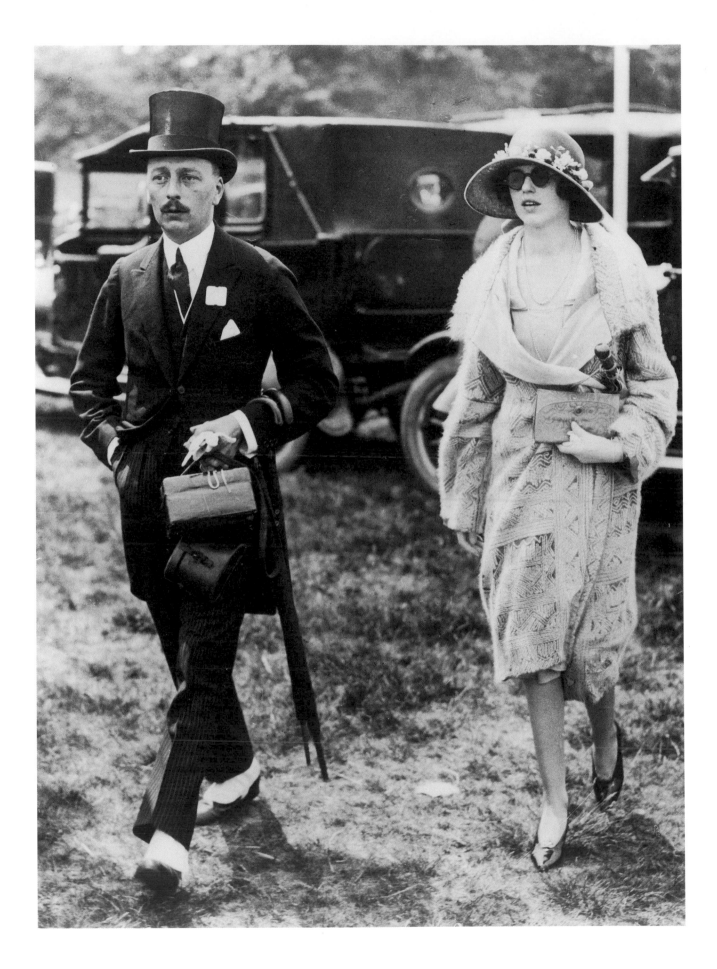

WHAT ARE YOU?

(from "Every-Day Characters: Portrait of a Lady")

W. M. Praed (1802–1839)

Was't in the north or south
 That summer breezes rocked your cradle?
And had you in your baby mouth
 A wooden or a silver ladle?
And was your first unconscious sleep
 By Brownie banned, or blessed by Fairy?
And did you wake to laugh or weep?
 And were you christened Maud or Mary?

And was your father called 'your grace'?
 And did he bet at Ascot races?
And did he chat of commonplace?
 And did he fill a score of places?
And did your lady-mother's charms
 Consist in picklings, broilings, bastings?
Or did she prate about the arms
 Her brave forefathers wore at Hastings?

SOMEBODY

Alfred, Lord Tennyson (1809–1892)

Somebody being a nobody,
Thinking to look like a somebody,
Said he thought me a nobody:
Good little somebody-nobody,
Had you not known me a somebody
Would you have called me a nobody?

FASHIONABLE COUPLE ATTENDING
THE RACES AT ASCOT, ENGLAND,
c. 1920s *(Photographer unknown)*

FOREIGN

Carol Ann Duffy (b. 1955)

Imagine living in a strange, dark city for twenty years.
There are some dismal dwellings on the east side
and one of them is yours. On the landing, you hear
your foreign accent echo down the stairs. You think
in a language of your own and talk in theirs.

Then you are writing home. The voice in your head
recites the letter in a local dialect; behind that
is the sound of your mother singing to you,
all that time ago, and now you do not know
why your eyes are watering and what's the word for this.

You use the public transport. Work. Sleep. Imagine one night
you saw a name for yourself sprayed in red
against a brick wall. A hate name. Red like blood.
It is snowing on the streets, under the neon lights,
as if this place were coming to bits before your eyes.

And in the delicatessen, from time to time, the coins
in your palm will not translate. Inarticulate,
because this is not home, you point at fruit. Imagine
that one of you says *Me not know what these people mean.
It like they only go to bed and dream.* Imagine that.

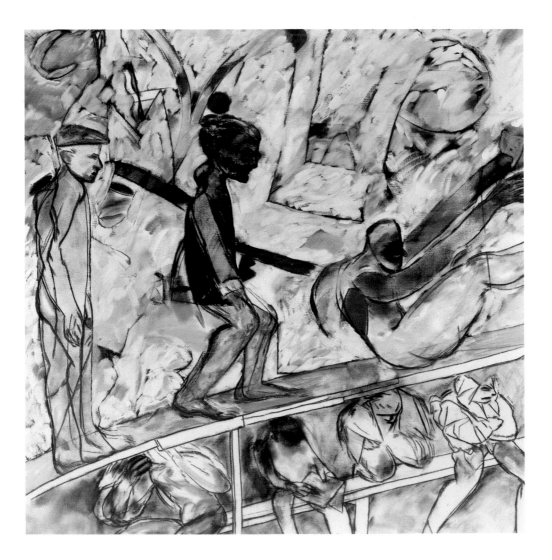

MY CITIES (AN EXPERI-
MENTAL DRAMA)
R. B. Kitaj (b. 1932)

Kitaj brings together ele-
ments of various cities where
he has "lived or loved," mixed
in with stumbling figures on
the catwalk and a baseball
dugout containing some of
his personal demons.

HALF-CASTE

John Agard (b. 1949)

Excuse me
standing on one leg
I'm half-caste

Explain yuself
wha yu mean
when yu say half-caste
yu mean when picasso
mix red an green
is a half-caste canvas/
explain yuself
wha yu mean
when yu say half-caste
yu mean when light an shadow
mix in de sky
is a half-caste weather/
well in dat case
england weather
nearly always half-caste
in fact some o dem cloud
half-caste till dem overcast
so spiteful dem dont want de sun pass
ah rass/
explain yuself
what yu mean
when yu say half-caste
yu mean tchaikovsky
sit down at dah piano
an mix a black key

wid a white key
is a half-caste symphony/

Explain yuself
wha yu mean
Ah listening to yu wid de keen
half of mih ear
Ah lookin at yu wid de keen
half of mih eye
an when I'm introduced to yu
I'm sure you'll understand
why I offer yu half-a-hand
an when I sleep at night
I close half-a-eye
consequently when I dream
I dream half-a-dream
an when moon begin to glow
I half-caste human being
cast half-a-shadow
but yu must come back tomorrow

wid de whole of yu eye
an de whole of yu ear
an de whole of yu mind

an I will tell yu
de other half
of my story

THUS LIVE WILL I

King Henry VIII (1491–1547)

Pastime with good company
I love and shall until I die.
Grudge who lust, but none deny,
So God be pleased thus live will I.
For my pastance
Hunt, sing and dance,
My heart is set.
All goodly sport
For my comfort—
Who shall me let?

Youth must have some dalliance,
Of good or ill some pastance.
Company me thinks the best,
All thoughts and fancies to digest,
For idleness
Is chief mistress
Of vices all—
Then who can say
But mirth and play
Is best of all?

Company with honesty
Is virtue—vices to flee.
Company is good and ill,
But every man hath his free will.
The best ensue,
The worst eschew,
My mind shall be;
Virtue to use,
Vice to refuse,
Thus shall I use me.

GOD SAVE THE KING

Henry Carey (c. 1687–1743)

God save our gracious King!
Long live our noble King!
 God save the King!
Send him victorious,
Happy and glorious,
Long to reign over us!
 God save the King!

O Lord our God, arise!
Scatter his enemies,
 And make them fall;
Confound their politics,
Frustrate their knavish tricks,
On Thee our hopes we fix—
 God save us all!

Thy choicest gifts in store
On him be pleased to pour;
 Long may he reign!
May he defend our laws,
And ever give us cause
To sing with heart and voice,
 God save the King!

KING AND QUEEN
*Henry Moore, OM, CH
(1898–1986)*

Moore said this sculpture
"has no reference to present-
day Royalty, but to a very
ancient idea of Royalty." In
the poem by King Henry
VIII, let means "to prevent."

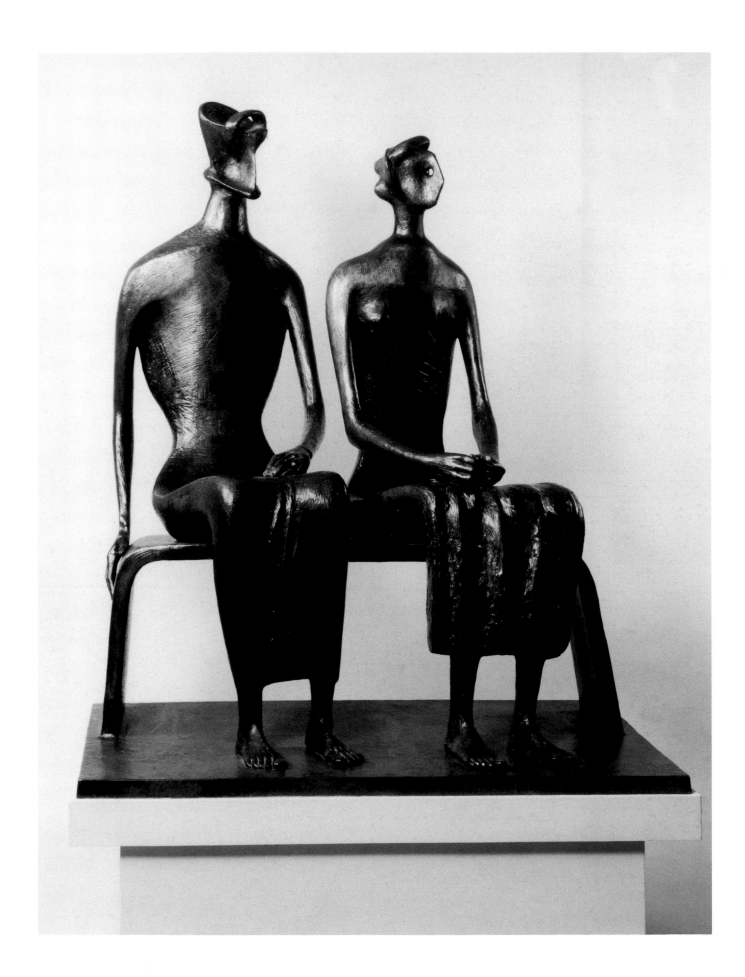

THE ANNIVERSARY

John Donne (1572–1631)

All Kings, and all their favourites,
 All glory of honours, beauties, wits,
The sun itself, which makes times, as they pass,
Is elder by a year now than it was
When thou and I first one another saw:
All other things to their destruction draw,
 Only our love hath no decay;
This no tomorrow hath, nor yesterday,
Running it never runs from us away,
 But truly keeps his first, last, everlasting day.

 Two graves must hide thine and mine corse;
 If one might, death were no divorce.
Alas, as well as other Princes, we
(Who Prince enough in one another be)
Must leave at last in death these eyes and ears,
Oft fed with true oaths, and with sweet salt tears;
 But souls where nothing dwells but love
(All other thoughts being inmates) then shall prove
This, or a love increasèd there above,
 When bodies in their graves, souls from their graves remove.

 And then we shall be thoroughly blest;
 But we no more than all the rest.
Here upon earth we're Kings, and none but we
Can be such Kings, nor of such subjects be;
Who is so safe as we? where none can do
Treason to us, except one of us two.
 True and false fears let us refrain,
Let us love nobly, and live, and add again
Years and years unto years, till we attain
 To write threescore: this is the second of our reign.

NO MAN IS AN ISLAND

(from *Devotions*, XVII)

John Donne (1572–1631)

No man is an island, entire of itself;
every man is a piece of the continent,
a part of the main;
if a clod be washed away by the sea,
Europe is the less,
as well as if a promontory were,
as well as if a manor of thy friends
or of thine own were;
any man's death diminishes me,
because I am involved in mankind;
and therefore never send to know
for whom the bell tolls;
it tolls for thee.

SOUND, SOUND THE CLARION

Thomas Osbert Mordaunt (1730–1809)

Sound, sound the clarion, fill the fife!
 Throughout the sensual world proclaim,
One crowded hour of glorious life
 Is worth an age without a name.

HAMMERSMITH BRIDGE ON
BOAT-RACE DAY
Walter Greaves (1846–1930)

Greaves was originally a
Thames boatman. Whistler
taught him to paint in exchange
for being rowed on the river.

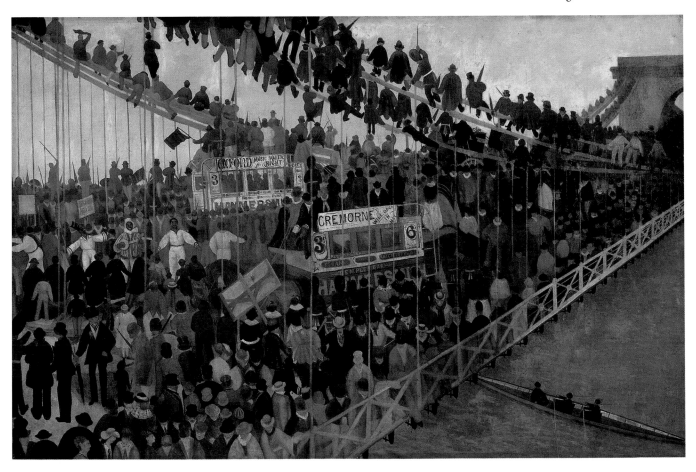

THIS ENGLAND: COMING OF AGE

TO A CHILD OF QUALITY

(Five Years Old, 1704. The Author then Forty)

Matthew Prior (1664–1721)

Lords, knights, and squires, the numerous band
 that wear the fair Miss Mary's fetters,
were summoned by her high command
 to show their passions by their letters.

My pen amongst the rest I took,
 lest those bright eyes, that cannot read,
should dart their kindling fire, and look
 the power they have to be obey'd.

Nor quality, nor reputation,
 forbid me yet my flame to tell;
dear Five-years-old befriends my passion
 and I may write till she can spell.

For, while she makes her silkworms beds
 with all the tender things I swear;
whilst all the house my passion reads,
 in papers round her baby's hair;

she may receive and own my flame,
 for, though the strictest prudes should know it,
she'll pass for a most virtuous dame,
 and I for an unhappy poet.

Then too, alas! when she shall tear
 the rhymes some younger rival sends,
she'll give me leave to write, I fear,
 and we shall still continue friends.

For, as our different ages move,
 'tis so ordained (would Fate but mend it!)
that I shall be past making love
 when she begins to comprehend it.

THE AGE OF INNOCENCE
Sir Joshua Reynolds (1723–1792)

Reynolds's sentimental paintings
of children are in sharp contrast
to his insightful portraits of
sophisticated adults, such as
Samuel Johnson and the actress
Sarah Siddons.

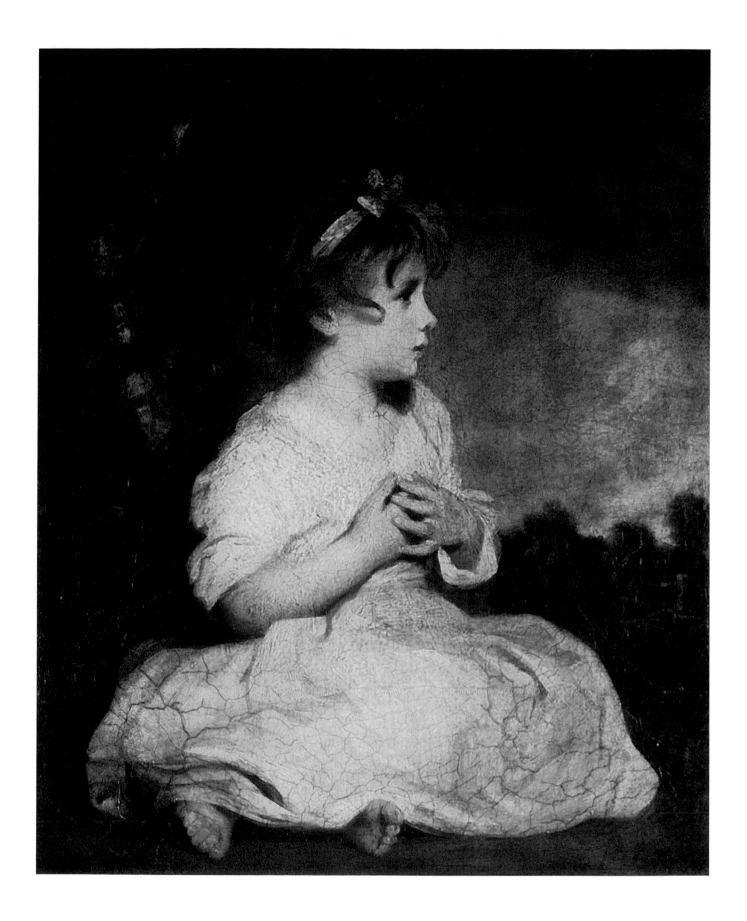

SONNET

John Milton (1608–1674)

How soon hath Time the subtle thief of youth,
Stol'n on his wing my three and twentieth year!
My hasting days fly on with full career,
But my late spring no bud or blossom shew'th.
Perhaps my semblance might deceive the truth,
That I to manhood am arriv'd so near,
And inward ripeness doth much less appear,
That some more timely-happy spirits endu'th.
Yet be it less or more, or soon or slow,
It shall be still in strictest measure ev'n,
To that same lot, however mean, or high,
Toward which Time leads me, and the will of Heav'n;
All is, if I have grace to use it so,
As ever in my great Task-Master's eye.

ONE-AND-TWENTY

Samuel Johnson (1709–1784)

Long expected one-and-twenty,
 ling'ring year, at length is flown:
pride and pleasure, pomp and plenty,
 Great * * * * * * *, are now your own.

Loosen'd from the minor's tether,
 free to mortgage or to sell,
wild as wind, and light as feather,
 bid the sons of thrift farewell.

Call the Betsies, Kates, and Jennies,
 all the names that banish care;
lavish of your grandsire's guineas,
 show the spirit of an heir.

All that prey on vice and folly
 joy to see their quarry fly:
there the gamester, light and jolly,
 there the lender, grave and sly.

Wealth, my lad, was made to wander,
 let it wander as it will;
call the jockey, call the pander,
 bid them come and take their fill.

When the bonny blade carouses,
 pockets full, and spirits high—
What are acres? What are houses?
 Only dirt, or wet or dry.

Should the guardian friend or mother
 tell the woes of wilful waste,
scorn their counsel, scorn their pother;—
 you can hang or drown at last!

YOUNG MAN AMONG ROSES
Nicholas Hilliard (1547–1619)

Best known for his miniature
portraits of famous contem-
poraries such as Queen
Elizabeth I, Hilliard here
depicts the joyous mood of
an anonymous youth in love.

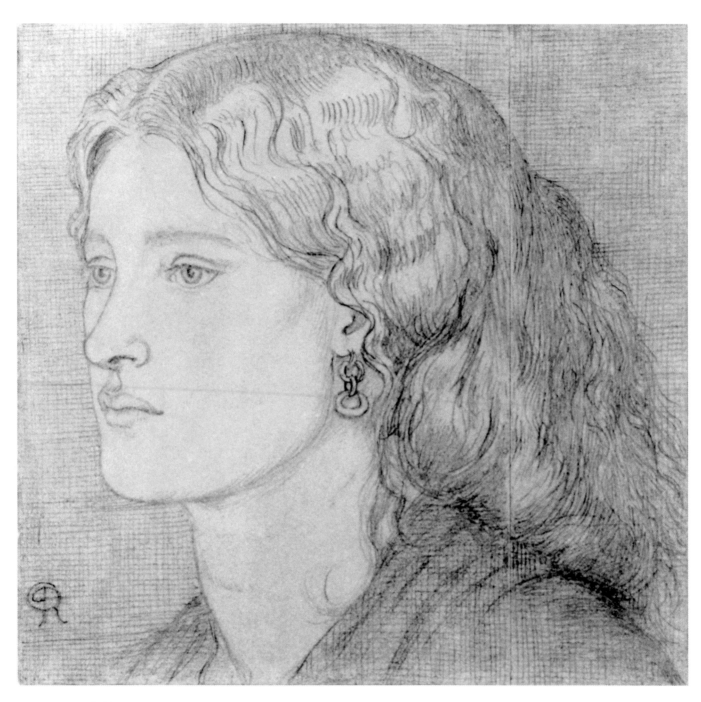

FANNY CORNFORTH
Dante Gabriel Rossetti (1828–1882)

A poet as well as a painter, Rossetti founded
the Pre-Raphaelite Brotherhood with
Hunt, Millais, and others, seeking to undo
many of the artistic developments initiated
by Italian artists in the sixteenth century.

THREE SHADOWS

Dante Gabriel Rossetti (1828–1882)

I looked and saw your eyes
 In the shadow of your hair,
As a traveller sees the stream
 In the shadow of the wood;
And I said, "My faint heart sighs,
 Ah me! to linger there,
To drink deep and to dream
 In that sweet solitude."

I looked and saw your heart
 In the shadow of your eyes,
As a seeker sees the gold
 In the shadow of the stream;
And I said, "Ah me! what art
 Should win the immortal prize,
Whose want must make life cold
 And Heaven a hollow dream?"

I looked and saw your love
 In the shadow of your heart,
As a diver sees the pearl
 In the shadow of the sea;
And I murmured, not above
 My breath, but all apart,—
"Ah! you can love, true girl,
 And is your love for me?"

SHE WALKS IN BEAUTY

George Gordon, Lord Byron (1788–1824)

She walks in beauty, like the night
 of cloudless climes and starry skies;
and all that's best of dark and bright
 meet in her aspect and her eyes;
thus mellow'd to that tender light
 which heaven to gaudy day denies.

One shade the more, one ray the less,
 had half impair'd the nameless grace
which waves in every raven tress,
 or softly lightens o'er her face;
where thoughts serenely sweet express
 how pure, how dear their dwelling-place.

And on that cheek, and o'er that brow,
 so soft, so calm, yet eloquent,
the smiles that win, the tints that glow,
 but tell of days in goodness spent,
a mind at peace with all below,
 a heart whose love is innocent!

HOW DO I LOVE THEE?
LET ME COUNT THE WAYS

Elizabeth Barrett Browning (1806–1861)

How do I love thee? Let me count the ways.
I love thee to the depth and breadth and height
my soul can reach, when feeling out of sight
for the ends of being and ideal grace,
I love thee to the level of everyday's
most quiet need, by sun and candle-light.
I love thee freely, as men strive for right;
I love thee purely, as they turn from praise.
I love thee with the passion put to use
in my old griefs, and with my childhood's faith.
I love thee with a love I seemed to lose
with my lost saints—I love thee with the breath,
smiles, tears, of all my life!—and, if God choose,
I shall but love thee better after death.

APRIL LOVE
Arthur Hughes (1832–1915)

Owned for a time by William
Morris, this romantic painting
includes symbols of eternal life
(the ivy) as well as love's tran-
sience (the fallen rose petals).

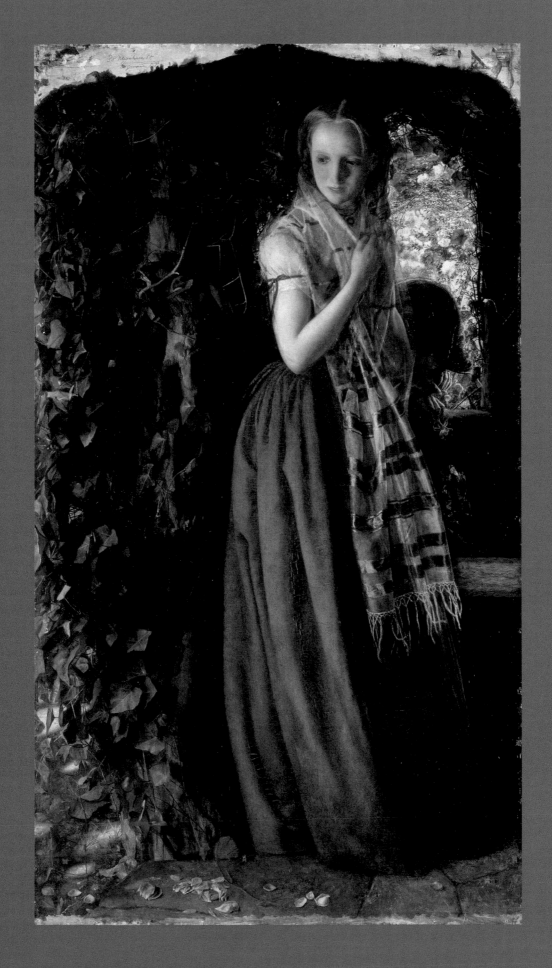

LIGHTS OUT

Edward Thomas (1878–1917)

I have come to the borders of sleep,
The unfathomable deep
Forest where all must lose
Their way, however straight,
Or winding, soon or late;
They cannot choose.

Many a road and track
That, since the dawn's first crack,
Up to the forest brink,
Deceived the travellers,
Suddenly now blurs,
And in they sink.

Here love ends,
Despair, ambition ends;
All pleasure and all trouble,
Although most sweet or bitter,
Here ends in sleep that is sweeter
Than tasks most noble.

There is not any book
Or face of dearest look
That I would not turn from now
To go into the unknown
I must enter, and leave, alone,
I know not how.

The tall forest towers;
Its cloudy foliage lowers
Ahead, shelf above shelf;
Its silence I hear and obey
That I may lose my way
And myself.

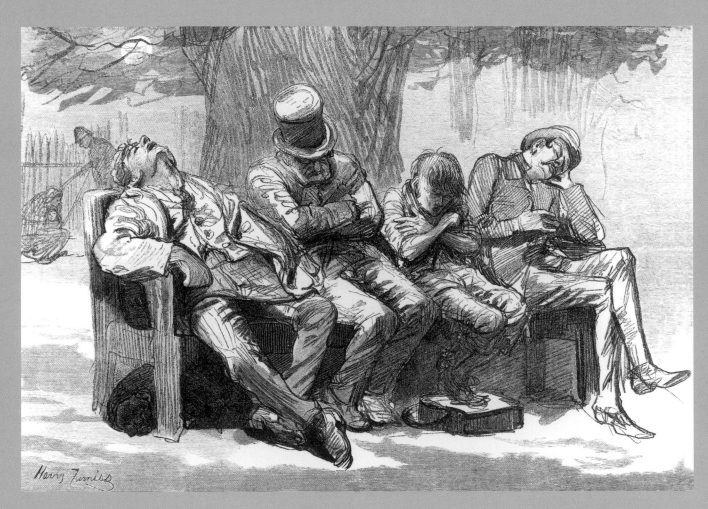

SLEEPING IN A LONDON PARK
ON A WARM SUMMER NIGHT
(Engraving for *The Illustrated
London News*, 1882, after a
drawing by Harry Furniss)

Some people may have done this
by choice; others, such as the
huddled mother and child in
the background, were probably
homeless.

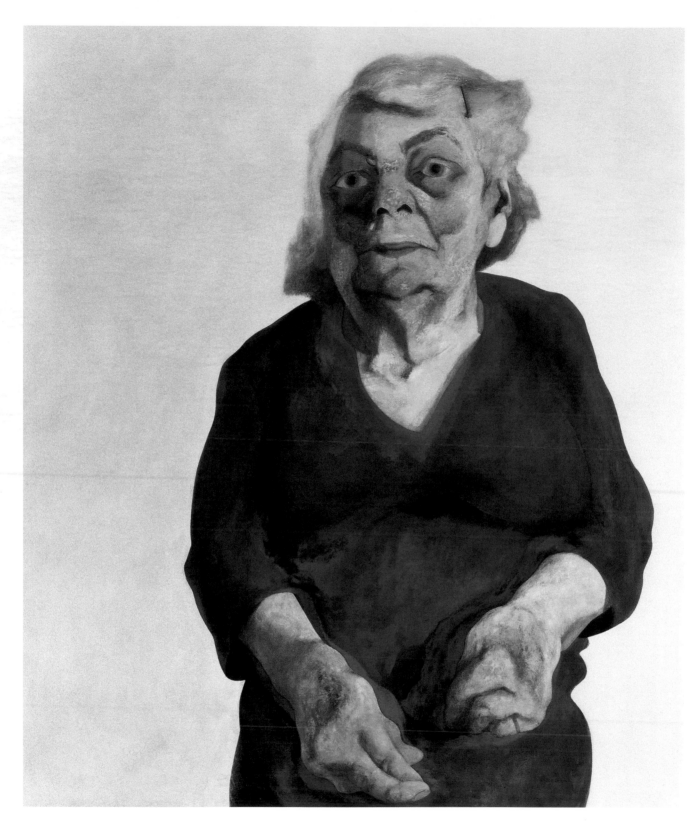

PORTRAIT OF FRANCES ROSE
Maggi Hambling (b. 1945)

The octogenarian Mrs. Rose, the painter's
next-door neighbor in Battersea, greatly
enjoyed sitting for her portrait.

THE THINGS THAT MATTER

Edith Nesbit (1858–1924)

Now that I've nearly done my days,
　And grown too stiff to sweep or sew,
I sit and think, till I'm amaze,
　About what lots of things I know:
Things as I've found out one by one—
　And when I'm fast down in the clay,
My knowing things and how they're done
　Will all be lost and thrown away.

There's things, I know, as won't be lost,
　Things as folks write and talk about:
The way to keep your roots from frost,
　And how to get your ink spots out.
What medicine's good for sores and sprains,
　What way to salt your butter down,
What charms will cure your different pains,
　And what will bright your faded gown.

But more important things than these,
　They can't be written in a book:
How fast to boil your greens and peas,
　And how good bacon ought to look;
The feel of real good wearing stuff,
　The kind of apple as will keep,
The look of bread that's rose enough,
　And how to get a child asleep.

Whether the jam is fit to pot,
　Whether the milk is going to turn,
Whether a hat will lay or not,
　Is things as some folks never learn.

I know the weather by the sky,
　I know what herbs grow in what lane;
And if sick men are going to die,
　Or if they'll get about again.

Young wives come in, a-smiling, grave,
　With secrets that they itch to tell:
I know what sort of times they'll have,
　And if they'll have a boy or gell.
And if a lad is ill to bind,
　Or some young maid is hard to lead,
I know when you should speak 'em kind,
　And when it's scolding as they need.

I used to know where birds ud set,
　And likely spots for trout or hare,
And God may want me to forget
　The way to set a line or snare;
But not the way to truss a chick,
　To fry a fish, or baste a roast,
Nor how to tell, when folks are sick,
　What kind of herb will ease them most!

Forgetting seems such silly waste!
　I know so many little things,
And now the Angels will make haste
　To dust it all away with wings!
O God, you made me like to know,
　You kept the things straight in my head,
Please God, if you can make it so,
　Let me know *something* when I'm dead.

COMPANIONS: A TALE TOLD BY A GRANDFATHER

C. S. Calverley (1831–1884)

I know not of what we ponder'd
 Or made pretty pretence to talk
As, her hand within mine, we wander'd
 Tow'rd the pool by the limetree walk,
While the dew fell in showers from the passion flowers
 And the blush-rose bent on her stalk.

I cannot recall her figure:
 Was it regal as Juno's own?
Or only a trifle bigger
 Than the elves who surround the throne
Of the Faëry Queen, and are seen, I ween,
 By mortals in dreams alone?

What her eyes were like, I know not:
 Perhaps they were blurr'd with tears;
And perhaps in your skies there glow not
 (On the contrary) clearer spheres.
No! as to her eyes I am just as wise
 As you or the cat, my dears.

Her teeth, I presume, were 'pearly':
 But which was she, brunette or blonde?
Her hair, was it quaintly curly,
 Or straight as a beadle's wand?
That I fail'd to remark;—it was rather dark
 And shadowy round the pond.

Then the hand that reposed so snugly
 In mine—was it plump or spare?
Was the countenance fair or ugly?
 Nay, children, you have me there!
My eyes were p'raps blurred; and besides I'd heard
 That it's horribly rude to stare.

And I—was I brusque and surly?
 Or oppressively bland and fond?

Was I partial to rising early?
 Or why did we twain abscond,
All breakfastless too, from the public view
 To prowl by a misty pond?

What pass'd, what was felt or spoken—
 Whether anything pass'd at all—
And whether the heart was broken
 That beat under that shelt'ring shawl—
(If shawl she had on, which I doubt)—has gone,
 Yes, gone from me past recall.

Was I haply the lady's suitor?
 Or her uncle? I can't make out—
Ask your governess, dears, or tutor.
 For myself I'm in hopeless doubt
As to why we were there, who on earth we were,
 And what this is all about.

FIGURE OF A WOMAN
Dame Barbara Hepworth (1903–1975)

Hepworth, who frequently worked in stone, said that she was fascinated "by the kind of form that grew out of achieving a personal harmony with the material."

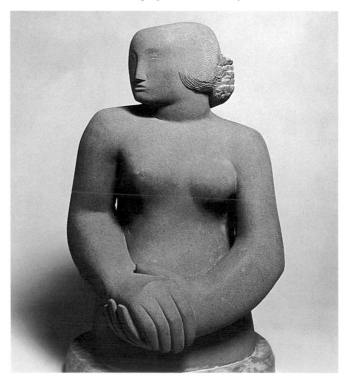

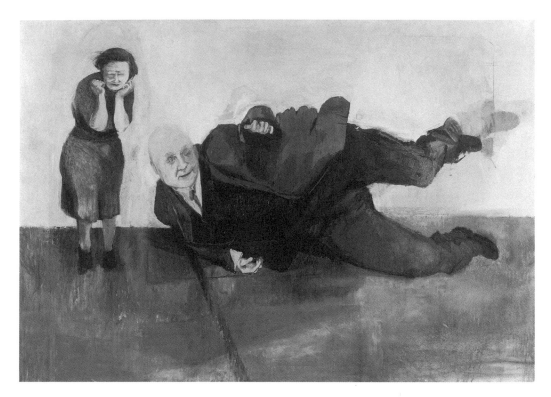

A MAN WHO SUDDENLY
FELL OVER
Michael Andrews (1928–1995)

Andrews painted this picture
for his diploma examination,
shortly before leaving art
school. He said it might
represent the uncertainty he
felt as he thought about his
future.

YOU ARE OLD, FATHER WILLIAM

Lewis Carroll (1832–1898)

'You are old, Father William,' the young man said,
 'And your hair has become very white;
And yet you incessantly stand on your head—
 Do you think, at your age, it is right?'

'In my youth,' Father William replied to his son,
 'I feared it might injure the brain;
But, now that I'm perfectly sure I have none,
 Why, I do it again and again.'

'You are old,' said the youth, 'as I mentioned before,
 And have grown most uncommonly fat;
Yet you turned a back-somersault in at the door—
 Pray, what is the reason of that?'

'In my youth,' said the sage, as he shook his grey locks,
 'I kept all my limbs very supple
By the use of this ointment—one shilling the box—
 Allow me to sell you a couple?'

'You are old,' said the youth, 'and your jaws are too weak
 For anything tougher than suet;
Yet you finished the goose, with the bones and the beak—
 Pray, how did you manage to do it?'

'In my youth,' said his father, 'I took to the law,
 And argued each case with my wife;
And the muscular strength, which it gave to my jaw,
 Has lasted the rest of my life.'

'You are old,' said the youth, 'one would hardly suppose
 That your eye was as steady as ever;
Yet you balance an eel on the end of your nose—
 What made you so awfully clever?'

'I have answered three questions, and that is enough,'
 Said his father. 'Don't give yourself airs!
Do you think I can listen all day to such stuff?
 Be off, or I'll kick you down-stairs!'

WE'LL GO NO MORE A-ROVING

George Gordon, Lord Byron (1788–1824)

So, we'll go no more a-roving
 so late into the night,
though the heart be still as loving,
 and the moon be still as bright.

For the sword outwears its sheath,
 and the soul wears out the breast,
and the heart must pause to breathe,
 and love itself have rest.

Though the night was made for loving,
 and the day returns too soon,
yet we'll go no more a-roving
 by the light of the moon.

71

Arthur Ransome (1884–1967)

Seventy one:
Seventy one!
It isn't much fun
To be Seventy one.
Wool's nearly spun:
Sand's nearly run:
The end has begun:
Life's nearly DONE.
It isn't much fun
To be seventy one.

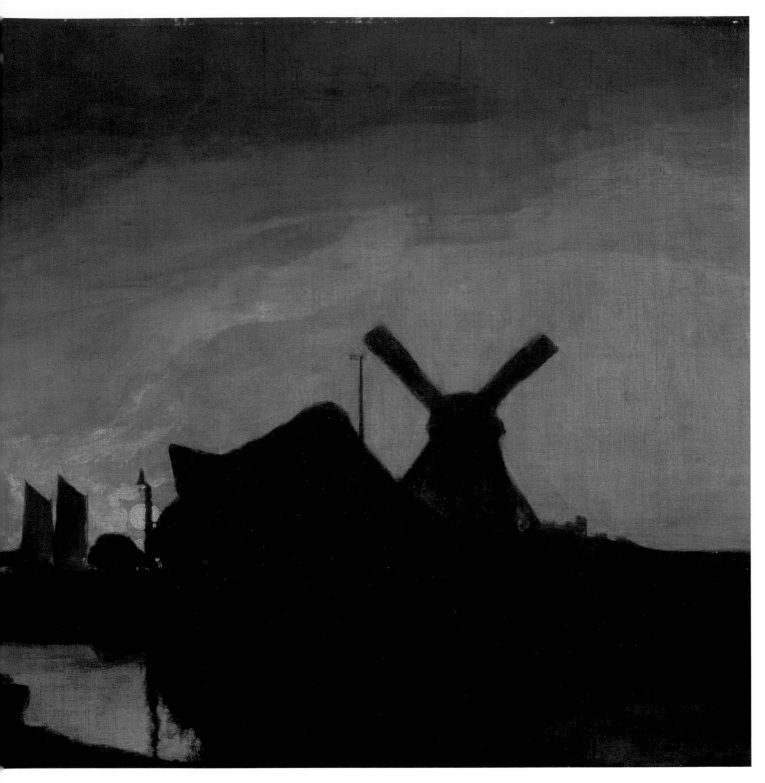

MOONRISE ON THE YARE
John Crome (1768–1821)

The river Yare, winding through the Norfolk Broads in southeastern England, is familiar to readers of Ransome's "Swallows and Amazons" books of sailing adventures.

OTHER KINGDOMS: WALES

THERE IS A CASTLE
(from "Branwen")

Wyn Griffith (20th century)

I have borne too long this burden
pressing the fibres of my heart into pain.
Old tunes and the green-mottled grey rock
above the bay drawn in a curve bow-taut,
old tunes and a cloud
from Snowdon driving valley-light over hills
to this dark headland. There is a castle now
upon Harlech old as a forgotten dream
but I cannot see it
nor with the touch of its worn stone
bring into life new thought new music new desires.
An old tune with the wind sharp as a harp-rustle
counterpointing this day into centuries of words
of notes of all I half-remember, old tunes, old tales.

Is there no escape?

No ease of this burden until I cast
each stone of this castle beyond the day
far into time unspent and with each stone
the lamentation of a brood of men who heard,
oh! and stood beyond their grief an instant
silent at your name, Branwen, Branwen.

THE PROUD AND MIGHTY
(From "Grongar Hill")

John Dyer (1700?–1758)

Gaudy as the opening dawn,
Lies a long and level lawn,
On which a dark hill, steep and high,
Holds and charms the wandering eye.
Deep are his feet in Towy's flood,
His sides are clothed with waving wood,
And ancient towers crown his brow,
That cast an awful look below;
Whose ragged walls the ivy creeps
And with her arms from falling keeps.

Yet time has seen that lifts the low,
And level lays the lofty brow,
Has seen the broken pile complete,
Big with the vanity of state.
But transient is the smile of fate;
A little rule, a little sway,
A sunbeam in a winter's day,
Is all the proud and mighty have
Between the cradle and the grave.

AN ANCIENT CASTLE
Sir Robert Ker Porter (1777–1842)

Having conquered England in 1066, the Normans
also took Wales and part of Ireland by force, build-
ing castles to consolidate their gains.

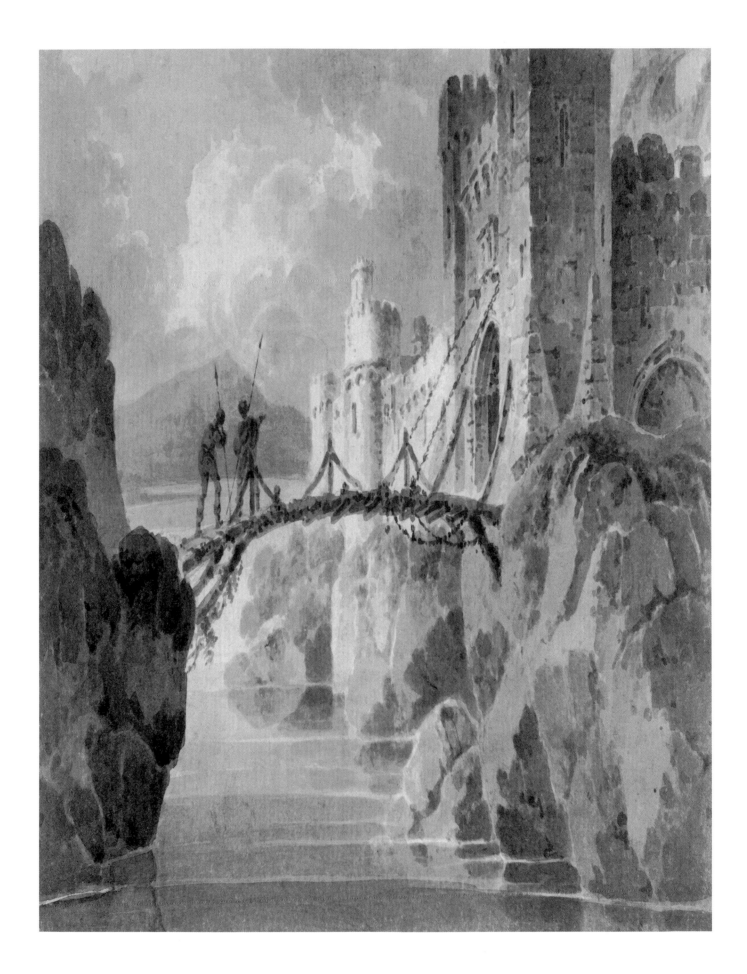

CWM FARM NEAR CAPEL CURIG

Huw Menai (20th century)

Some cool medieval calm hath settled here
 on this lone farmstead, wherein humble folk
 still speak the tongue that Owain Glyndwr spoke,
and worship in it, too, the God they fear.
For to these perilous ways, where rocks rise sheer,
 their kinsmen came to curse the tyrant yoke;
 and here the proud invader's heart was broke
by brave and stubborn men year after year.
Unconquerable still! here birds but know
 the Cymric speech; the very mountains brood
o'er consonants that, rugged streamlets, flow
 into deep vowel lakes . . . and by this wood,
 where Prince Llywelyn might himself have stood
forget-me-nots in wild profusion grow.

IN THE VALLEY OF THE ELWY

Gerard Manley Hopkins (1844–1889)

I remember a house where all were good
 To me, God knows, deserving no such thing:
 Comforting smell breathed at very entering,
Fetched fresh, as I suppose, off some sweet wood.
That cordial air made those kind people a hood
 All over, as a bevy of eggs the mothering wing
 Will, or mild nights the new morsels of spring:
Why, it seemed of course; seemed of right it should.

Lovely the woods, waters, meadows, combes, vales,
All the air things wear that build this world of Wales;
 Only the inmate does not correspond:
God, lover of souls, swaying considerate scales,
Complete thy creature dear O where it fails,
 Being mighty a master, being a father and fond.

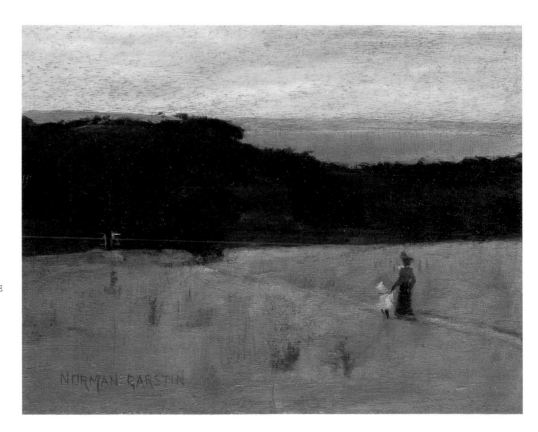

MOUNT'S BAY AND TOLCARNE FROM TREWIDDEN FARM FOOTPATH WITH ALETHEA AND HER MOTHER
Norman Garstin (1847–1926)

The artist's wife and daughter were included in this impressionistic landscape of Wales.

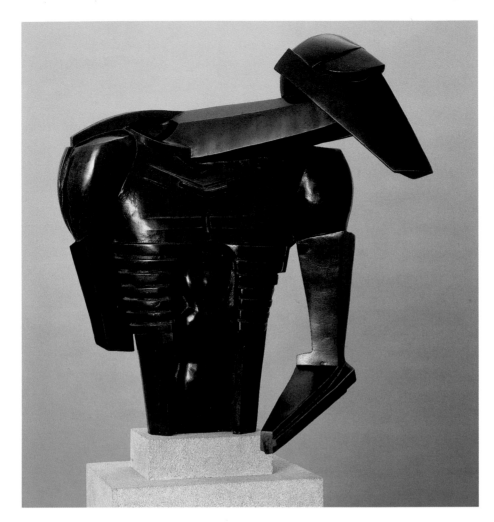

**TORSO IN METAL FROM
"THE ROCK DRILL"**
Sir Jacob Epstein (1880–1959)

In the original sculpture Epstein
included an actual pneumatic
drill, and he considered adding
a motor so that the piece could
move. After World War I he
removed everything but the
torso of a mutilated figure.

ECHOES

(from *Life and Death*)

William Ernest Henley (1849–1903)

Out of the night that covers me,
 Black as the Pit from pole to pole,
I thank whatever gods may be
 For my unconquerable soul.

In the fell clutch of circumstance
 I have not winced nor cried aloud.
Under the bludgeoning of chance
 My head is bloody, but unbowed.

Beyond this place of wrath and tears
 Looms but the horror of the shade,
And yet the menace of the years
 Finds, and shall find, me unafraid.

It matters not how strait the gate,
 How charged with punishments the scroll,
I am the master of my fate:
 I am the captain of my soul.

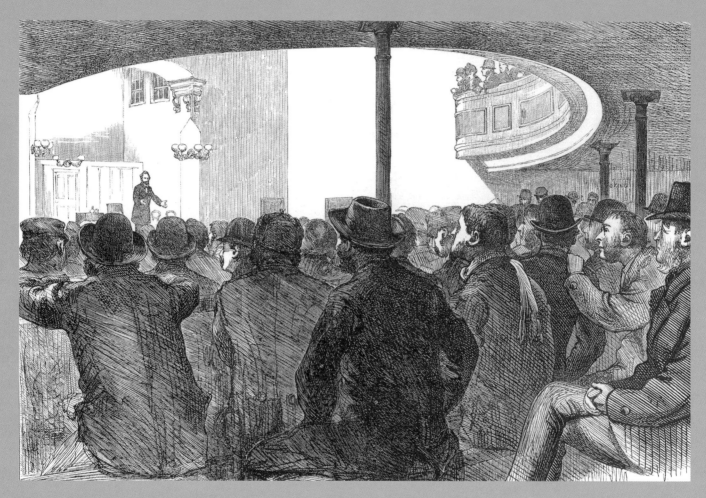

LOCKED-OUT WORKERS LISTEN TO AN EMIGRATION
AGENT LECTURING IN THE TEMPERANCE HALL AT
MERTHYR TYDFIL, CARMARTHERNSHIRE, WALES
(Published in *The Illustrated London News*, 1875)

As the lockout of factories and mines continued,
some Welshmen moved to England or the
Continent, while others migrated to Australia,
Canada, the United States, and elsewhere.

FROM EXILE

Dafydd Benfras (13th century)

Translated from the Welsh by Tony Conran

It's bright the icy foam as it flows,
It's fierce in January great sea tumult,
It's woe's me the language, long-wished-for speech
For the sake of tales, would be sweet to my ear.

Ability in English I never had,
Neither knew phrases of passionate French:
A stranger and foolish, when I've asked questions
It turned out crooked—I spoke North Welsh!

On a wave may God's son grant us our wish
And out from amongst them readily bring us
To a Wales made one, contented and fair,
To a prince throned, laden nobly with gifts,
To the lord of Dinorwig's bright citadel land,
To the country of Dafydd, where Welsh freely flows!

YOUTH

Keidrych Rhys (20th century)

I try to remember the things
at home that mean Wales but typical
isn't translated across
the Channel: I try to create,
doors grow into masts, love losses
in the village wood, but boyhood's
fear fled into the pale skeleton
of the dark mountain, into
the bilingual valley filled
through a sail-hole of my drying
feelings. But I try. Lightning
is different in Wales.

A WELSH FUNERAL,
BETWYS-Y-COED
David Cox (1783–1859)

Cox and Hopkins both
spent long periods of
time in Wales, observ-
ing the local people
and their customs.

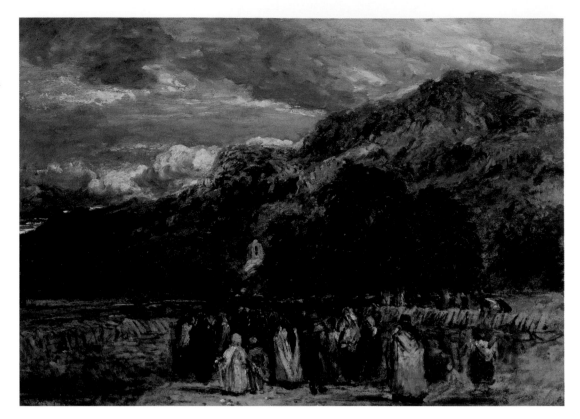

FELIX RANDAL

Gerard Manley Hopkins (1844–1889)

Felix Randal the farrier, O he is dead then? my duty all ended,
who have watched his mould of man, big-boned and hardy-handsome
pining, pining, till time when reason rambled in it and some
fatal four disorders, fleshed there, all contended?

Sickness broke him. Impatient he cursed at first, but mended
being anointed and all; though a heavenlier heart began some
months earlier, since I had our sweet reprieve and ransom
tendered to him. Ah well, God rest him all road ever he offended!

This seeing the sick endears them to us, us too it endears.
My tongue had taught thee comfort, touch had quenched thy tears,
thy tears that touched my heart, child, Felix, poor Felix Randal;

how far from then forethought of, all thy more boisterous years,
when thou at the random grim forge, powerful amidst peers,
didst fettle for the great grey drayhorse his bright and battering sandal!

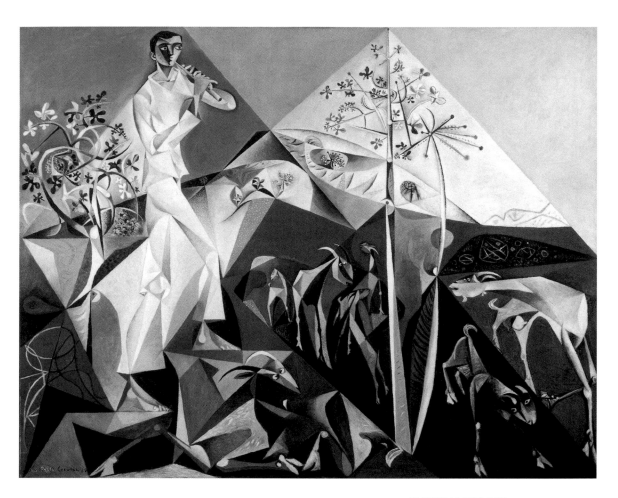

PASTORAL FOR P.W.
John Craxton (b. 1922)

"P.W." was Peter Watson, a patron of
the arts for whom Craxton painted this
"celebration of the power of music."

TO THE NOBLE WOMAN
OF LLANARTH HALL

(Who shut the Author's goat in a house for
two days, its crime being that it grazed too
near the Mansion)

Evan Thomas (c. 1710–c. 1770)

Translated from the Welsh by Tony Conran

O black-maned, horse-haired, unworthy one,
　　what did you do to the goat, your sister?
She'd your father's horns, your mother's beard—
　　why did you put her falsely in prison?

MUSIC HAS CHARMS

(from "The Mourning Bride")

William Congreve (1670–1729)

Music has charms to soothe a savage breast,
To soften rocks, or bend a knotted oak.
I've read that things inanimate have moved,
And, as with living souls, have been informed,
By magic numbers and persuasive sound. . . .

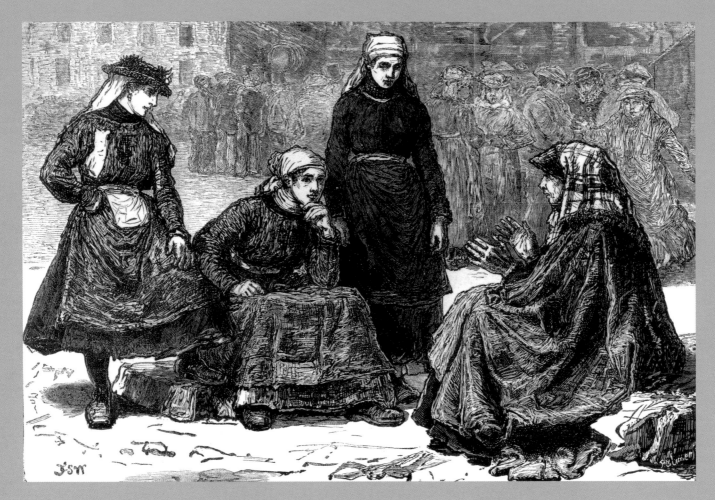

WOMEN DISCUSSING THE LOCKOUT OF
WORKERS IN SOUTH WALES (J. S. W. for
The Illustrated London News, 1875, after
a drawing by P. C. Limers)

Before the days of labor unions, factory
and mine owners could sometimes win
disputes by temporarily closing their doors.

I'R HEN IAITH A'I CHANEUON

Walter Dowding (20th century)

When I am listening to the sweet, tuneful airs of my country,
sung by fresh and young Welsh voices that love them,
in the language so strong and beautiful,
that has grown out of the ageless mountains
and the deep, dark valleys,
I am fulfilled as I am in no otherwise fulfilled.

Then am I caught up into a realm of natural being,
and am one with my fathers,
and with them that shall come after me,
and with those who yet, in these so unregenerate days,
do speak that speech of wondrous beauty
that our fathers wrought.

SONA DIALECT

David Evans (20th century)

Gettown fro their you
break for your whipcords
if yor dunnot gettown
hau casol for the jawl bach.

gum, wheezie creekie, tellum a story
of Corris and god's big gutter.

oh behewtiful, yes yes the pickcutter
Ilan of Pwllgwaelod. . . .

Ilan, Ilan always mam
Mam a good whilber-ful mam.

jawl gettown by there willewe
heil give it story orright
crack your stick, willewe, defile
you crack neck meboy
munjawl all always wears in this
Wales.

ATTRACTION

Anonymous (16th–17th century)

Translated from the Welsh by Tony Conran

Never for more than a year stay in England,
 a place bleak and wretched;
where the bird is first nurtured
is the place he'll always seek.

PAINTED IN A WELSH VILLAGE
Albert Houthuesen (1903–1979)

In his poetry, Thomas returned
again and again to childhood
scenes that might have been
more imaginary than real.

POEM IN OCTOBER

Dylan Thomas (1914–1953)

It was my thirtieth year to heaven
woke to my hearing from harbour and neighbour wood
 and the mussel pooled and the heron
 priested shore
 the morning beckon
with water praying and call of seagull and rook
and the knock of sailing boats on the net webbed wall
 myself to set foot
 that second
 in the still sleeping town and set forth.

 My birthday began with the water-
birds and the birds of the winged trees flying my name
 above the farms and the white horses
 and I rose
 in rainy autumn
and walked abroad in a shower of all my days.
High tide and the heron dived when I took the road
 over the border
 and the gates
 of the town closed as the town awoke.

 A springful of larks in a rolling
cloud and the roadside bushes brimming with whistling
 blackbirds and the sun of October
 summery
 on the hill's shoulder,
here were fond climates and sweet singers suddenly
come in the morning where I wandered and listened
 to the rain wringing
 wind blow cold
 in the wood faraway under me.

 Pale rain over the dwindling harbour
and over the sea wet church the size of a snail
 with its horns through mist and the castle
 brown as owls
 but all the gardens

of spring and summer were blooming in the tall tales
beyond the border and under the lark full cloud.
 There I could marvel
 my birthday
 away but the weather turned around.

 It turned away from the blithe country
and down the other air and the blue altered sky
 streamed again a wonder of summer
 with apples
 pears and red currants
and I saw in the turning so clearly a child's
forgotten mornings when he walked with his mother
 through the parables
 of sun light
 and the legends of the green chapels

 and the twice told fields of infancy
that his tears burned my cheeks and his heart moved in mine.
 These were the woods the river and sea
 where a boy
 in the listening
summertime of the dead whispered the truth of his joy
to the trees and the stones and the fish in the tide.
 And the mystery
 sang alive
 still in the water and singingbirds.

 And there could I marvel my birthday
away but the weather turned around. And the true
 joy of the long dead child sang burning
 in the sun.
 It was my thirtieth
year to heaven stood there then in the summer noon
though the town below lay leaved in October blood.
 O may my heart's truth
 still be sung
 on this high hill in a year's turning.

WHAT PASSES AND ENDURES

(in memory of a Welsh scholar)

John Ceiriog Hughes (1832–1887)

Translated from the Welsh by Tony Conran

Still do the great mountains stay,
 and the winds above them roar;
there is heard at break of day
 songs of shepherds as before.
Daisies as before yet grow
 round the foot of hill and rock;
over these old mountains, though,
 a new shepherd drives his flock.

To the customs of old Wales
 changes come from year to year;
every generation fails,
 one has gone, the next is here.
After a lifetime tempest-tossed
 Alun Mabon is no more,
but the language is not lost
 and the old songs yet endure.

AN AUTOBIOGRAPHY

Ernest Rhys (1859–1946)

Wales England wed; so I was bred. 'Twas merry
 London gave me breath.
I dreamt of love, and fame: I strove. But Ireland taught
 me love was best:
and Irish eyes, and London cries, and streams of Wales
 may tell the rest.
What more than these I ask'd of Life I am content to
 have from Death.

INTERNATIONAL VELVET

(Song lyrics)

Catatonia (band formed in 1992)

Deffrwch Cymry cysglyd gwlad y gan
dwfn yw'r gwendid
bychan yw y fflam
Creulon yw'r cynhaeaf
ond per yw'r don
'Da' alaw'r alarchunig
yn fy mron

(Wake up sleepy Wales, land of song
Deep is the weakness, tiny is the flame
The Autumn is cruel, but the note is pure
With the melody of the lonely swan in my breast)

Every day when I wake up
I thank the lord I'm welsh

Darganfyddais gwir baradwys Rhyl
Gweledd o fedd gynhhyrfodd Cymraes swil

(A feast of mead invigorated a shy Welsh woman
And I discovered the true paradise of Rhyl)

Every day when I wake up
I thank the lord I'm welsh.

CATATONIA, WELSH BAND whose albums *International Velvet* and *Equally Cursed and Blessed* were #1 platinum hits in the United Kingdom.

The band members are singer Cerys Matthews, Mark Roberts (guitar), Paul Jones (bass), Aled Richards (drums), and Owen Powell (guitar).

OTHER KINGDOMS: SCOTLAND

WHAT DOES MY LIFE SERVE?

Mary Stuart, Queen of Scots (1542–1587)

Translated from the French by Charles Sullivan

What am I, alas,
and what does my life serve?
I am merely a body without heart,
a useless shadow, an object of misfortune,
who yearns for nothing but to die.

Oh, my enemies, bear no more hatred
toward one who has lost the will to greatness,
who is already consumed by overwhelming grief:
your rage will soon be gratified.

And you, my friends, who have held me dear,
remember that without good fortune, without health,
I could not accomplish anything of value.
Therefore wish an end to misery, and wish
that, having been punished enough on earth,
I may get my share of joy in heaven.

PORTRAIT OF MARY QUEEN
OF SCOTS
Nicholas Hilliard (1547–1619)

One of the most colorful figures
in the history of the British Isles,
Mary Stuart wrote vivid poetry
in French. After a short lifetime
(1542–1587) of adventure and
intrigue, she was executed by
order of Elizabeth I, who feared
her as a rival for the throne of
England.

MA= RIA.

Regina Scotiæ.

IN THE HIGHLANDS

Robert Louis Stevenson (1850–1894)

In the highlands, in the country places,
where the old plain men have rosy faces,
 and the young fair maidens
 quiet eyes;
where essential silence cheers and blesses,
and for ever in the hill-recesses
 her more lovely music
 broods and dies—

O to mount again where erst I haunted;
where the old red hills are bird-enchanted,
 and the low green meadows
 bright with sward;
and when even dies, the million-tinted,
and the night has come, and planets glinted,
 lo, the valley hollow
 lamp-bestarred!

O to dream, O to awake and wander
there, and with delight to take and render,
 through the trance of silence
 quiet breath!
Lo! for there, among the flowers and grasses,
only the mightier movement sounds and passes;
 only the winds and rivers,
 life and death.

QUEEN VICTORIA AT THE FALLS
OF THE GLASSALT RIVER, DURING
A VISIT TO THE SCOTTISH HIGH-
LANDS (W. J. Palmer, Jr., for *The
Illustrated London News,* 1880)

Tartan plaids, such as those
worn by two men in kilts shown
here, became socially acceptable
because of the Queen's interest
in Scotland. They had previously
been banned, after 1746, as part
of England's effort to suppress
the Scottish clans.

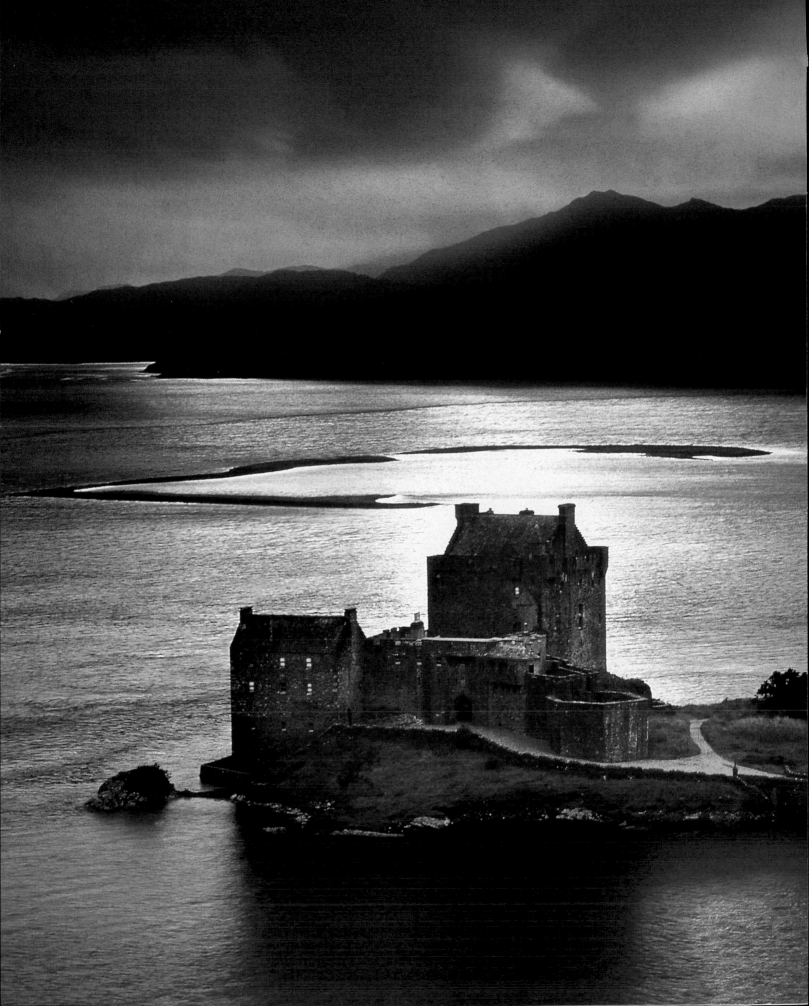

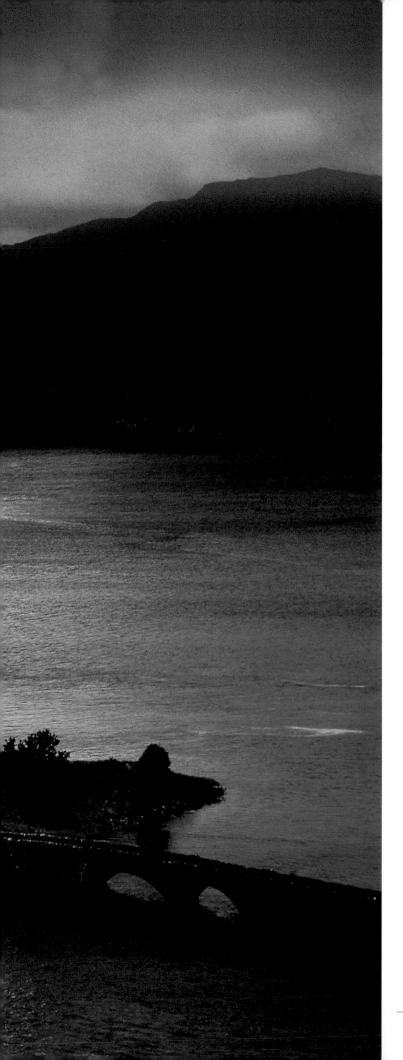

BLOW, BUGLE, BLOW
(from "The Princess")

Alfred, Lord Tennyson (1809–1892)

The splendour falls on castle walls
and snowy summits old in story:
the long light shakes across the lakes,
and the wild cataract leaps in glory.

Blow, bugle, blow, set the wild echoes flying,
blow, bugle; answer, echoes, dying, dying, dying.

O hark, O hear! how thin and clear,
and thinner, clearer, farther going!
O sweet and far from cliff and scar
the horns of Elfland faintly blowing!

Blow, let us hear the purple glens replying:
blow, bugle; answer, echoes, dying, dying, dying.

O love, they die in yon rich sky,
they faint on hill or field or river:
our echoes roll from soul to soul,
and grow for ever and for ever.

Blow, bugle, blow, set the wild echoes flying,
and answer, echoes, answer, dying, dying, dying.

EILEAN DONAN CASTLE
Ernest Nägele (b. 1934)

This strategic fortress in western
Scotland was held for centuries by the
MacKenzie and MacRae clans. Destroyed
in 1719, it was purchased and rebuilt in
1912–32 by John MacRae-Gilstrap.

OUR HIGH-PLACED MACBETH
(from *Macbeth*, Act IV, Scene 1)

William Shakespeare (1564–1616)

*(Thunder. Third Apparition: a Child crowned,
with a tree in his hand.)*

THIRD APPARITION:
Be lion-mettled, proud; and take no care
Who chafes, who frets, or where conspirers are:
Macbeth shall never vanquish'd be until
Great Birnham wood to high Dunsinane hill
Shall come against him.

(Descends)

MACBETH:
 That will never be:
Who can impress the forest, bid the tree
Unfix his earth-bound root? Sweet bodements! good!
Rebellion's head, rise never till the wood
Of Birnham rise, and our high-placed Macbeth
Shall live the lease of nature, pay his breath
To time and mortal custom. . . .

HIGHLAND CEARNICH
DEFENDING A PASS
(Engraving for *The Illustrated
London News,* 1843, after a
painting by R. R. M'lan)

The original picture, exhibited
at London's Royal Academy, was
thought to represent the history
of many "desperate encounters"
in the Highland glens of Scotland.

EDINBURGH CASTLE: MARCH
OF THE HIGHLANDERS
J. M. W. Turner (1775–1851)

Turner attempted to illustrate Sir Walter Scott's novels, but Scott
complained that the artist included "highlanders in every
Scottish scene"; not everyone he wrote about was a clansman.

SCOTS MARCHING TO THE BORDER

(from *The Monastery*, Chapter XXV)

Sir Walter Scott (1771–1832)

March, march, Ettrick and Teviotdale,
 why the deil dinna ye march forward in order?
March, march, Eskdale and Liddesdale,
 all the Blue Bonnets are bound for the Border.
 Many a banner spread,
 flutters above your head,
 many a crest that is famous in story.
 Mount and make ready then,
 sons of the mountain glen,
 fight for the Queen and the old Scottish glory.

Come from the hills where your hirsels are grazing,
 come from the glen of the buck and the roe;
come to the crag where the beacon is blazing,
 come with the buckler, the lance, and the bow.
 Trumpets are sounding,
 war-steeds are bounding,
stand to your arms then, and march in good order;
 England shall many a day
 tell of the bloody fray,
 when the Blue Bonnets came over the Border.

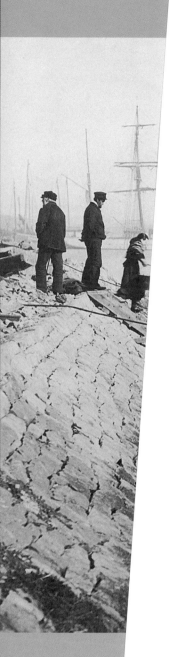

RETURN FRO...
19TH CENTU...

People of n...
still make a...
Romans, C...
once fared.

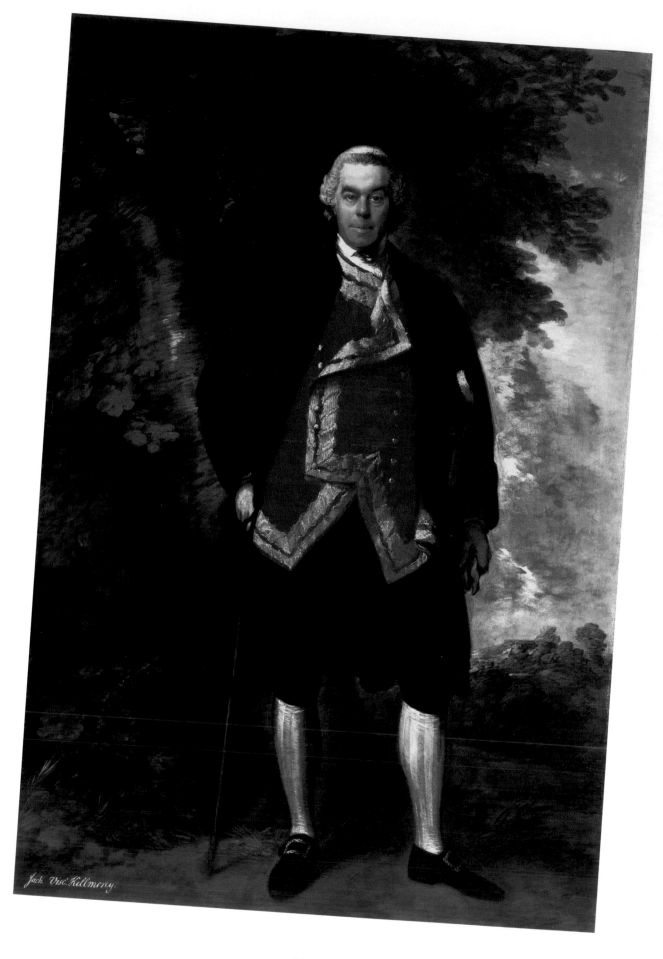

Jack Visc. Kilmorey.

THE PATRIOT

Sir Walter Scott (1771–1832)

Breathes there the man, with soul so dead,
Who never to himself hath said,
 This is my own, my native land!
Whose heart hath ne'er within him burned,
As home his footsteps he hath turned,
 From wandering on a foreign strand!
If such there breathe, go, mark him well;
For him no Minstrel raptures swell;
High though his titles, proud his name,
Boundless his wealth as wish can claim;
Despite those titles, power, and pelf,
The wretch, concentred all in self,
Living, shall forfeit fair renown,
And, doubly dying, shall go down
To the vile dust, from whence he sprung,
Unwept, unhonoured, and unsung.

O Caledonia! stern and wild,
Meet nurse for a poetic child!
Land of brown heath and shaggy wood,
Land of the mountain and the flood,
Land of my sires! what mortal hand
Can e'er untie the filial band,
That knits me to thy rugged strand!
Still, as I view each well known scene,
Think what is now, and what hath been,
Seems as, to me, of all bereft,
Sole friends thy woods and streams were left;
And thus I love them better still,
Even in extremity of ill.
By Yarrow's stream still let me stray,
Though none should guide my feeble way;
Still feel the breeze down Ettrick break,
Although it chill my withered cheek;
Still lay my head by Teviot Stone,
Though there, forgotten and alone,
The Bard may draw his parting groan.

JOHN NEEDHAM, 10TH
VISCOUNT KILMOREY
*Thomas Gainsborough
(1727–1788)*

Painted soon after Kilmorey
inherited his title, this portrait
conveys both pride and good
humor, a balance that the poet
Scott did not always achieve in
his writing.

THE WAY MY MOTHER SPEAKS

Carol Ann Duffy (b. 1955)

I say her phrases to myself
in my head
or under the shallows of my breath,
restful shapes moving.
The day and ever. The day and ever.

The train this slow evening
goes down England
browsing for the right sky,
too blue swapped for a cool grey.
For miles I have been saying
What like is it
the way I say things when I think.
Nothing is silent. Nothing is not silent.
What like is it.

Only tonight
I am happy and sad
like a child
who stood at the end of summer
and dipped a net
in a green, erotic pond. *The day
and ever. The day and ever.*
I am homesick, free, in love
with the way my mother speaks.

POETRY

Tom Leonard (b. 1944)

The pee as in pulchritude,
oh pronounced ough
as in bough

the ee rather poised
(pronounced ih as in wit)
then a languid high tea . . .

pause: then the coda—
ray pronounced rih
with the left eyebrow raised
—what a gracious bouquet!

Poetry.
Poughit. rih.

That was my education
—and nothing to do with me.

A map turned on its side, this wall relief is colorful and lively from a distance. From up close the viewer can see that the work is composed of innumerable pieces of trash, gathered from the streets and vacant lots of west London.

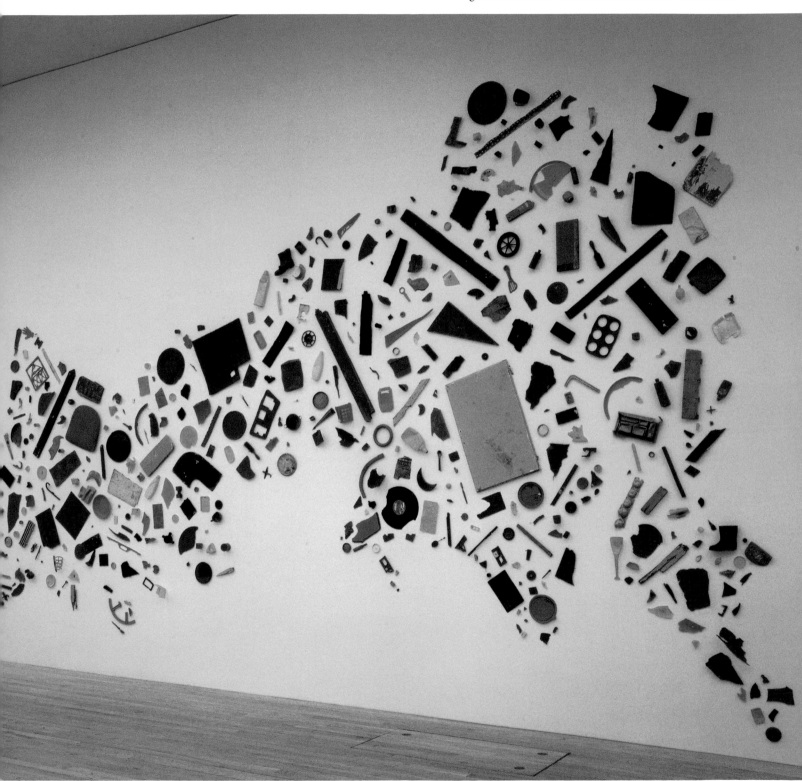

OTHER KINGDOMS: IRELAND

WE ARE NOT THE FIRST
(from *King Lear*, Act V, Scene 3)

William Shakespeare (1564–1616)

(Enter, in conquest, with drums and colours, Edmund; Lear and Cordelia, prisoners; Captains, Soldiers, &c.)

CORDELIA:
We are not the first
Who, with best meaning, have incurr'd the worst.
For thee, oppressed king, am I cast down;
Myself could else out-frown false fortune's frown.
Shall we not see these daughters and these sisters?

LEAR:
No, no, no, no! Come, let's away to prison:
We two alone will sing like birds i' the cage:
When thou dost ask me blessing, I'll kneel down,
And ask of thee forgiveness: so we'll live,

And pray, and sing, and tell old tales, and laugh
At gilded butterflies, and hear poor rogues
Talk of court news; and we'll talk with them too,
Who loses and who wins; who's in, who's out;
And take upon 's the mystery of things,
As if we were God's spies: and we'll wear out,
In a wall'd prison, packs and sects of great ones,
That ebb and flow by th' moon.

EDMUND:
 Take them away.

LEAR:
Upon such sacrifices, my Cordelia,
The gods themselves throw incense. . . .

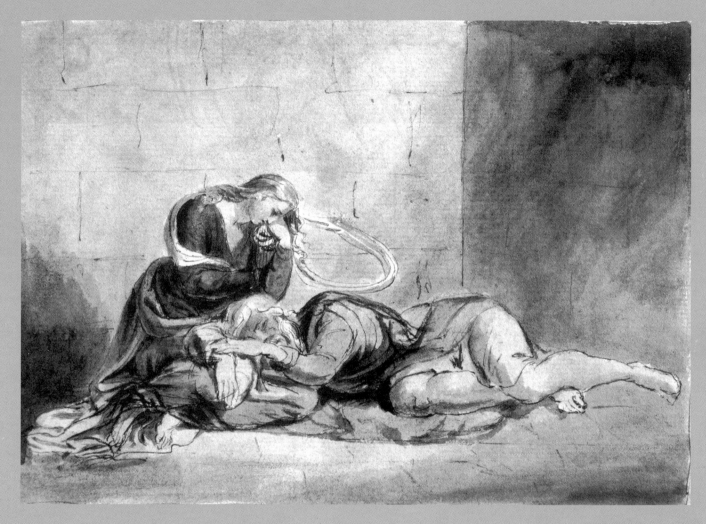

LEAR AND CORDELIA IN PRISON
William Blake (1757–1827)

Blake, a poet as well as a graphic
artist, had a lifelong interest in
myths and prophecies. Shakespeare's
character King Lear may derive from
the mythical Lir of Irish folklore.

TO A CHILD DANCING
IN THE WIND

W. B. Yeats (1865–1939)

Dance there upon the shore;
What need have you to care
For wind or water's roar?
And tumble out your hair
That the salt drops have wet;
Being young you have not known
The fool's triumph, nor yet
Love lost as soon as won,
Nor the best labourer dead
And all the sheaves to bind.
What need have you to dread
The monstrous crying of wind?

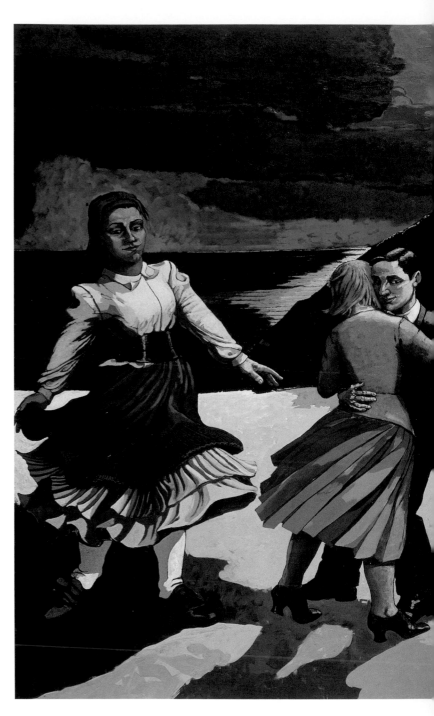

THE DANCE
Paula Rego (b. 1935)

This dreamlike painting is thought
by some viewers to represent
the stages of a woman's life from
childhood to old age.

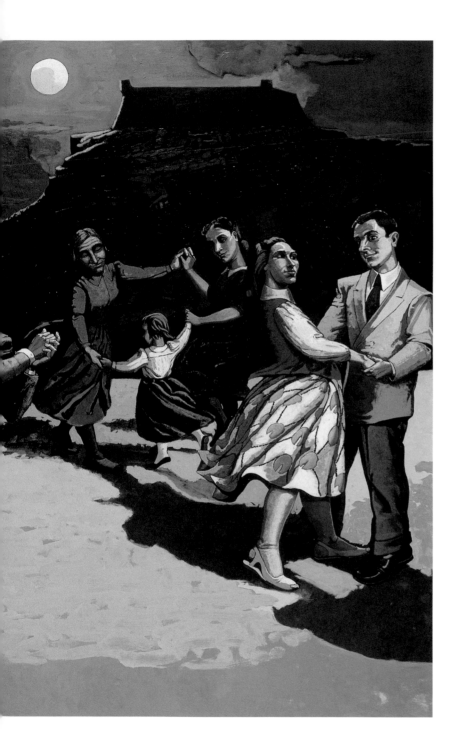

THE DANCE HALF DONE

Mary Ann Larkin (b. 1945)

Our fate was settled centuries ago
when the huge ice floes cracked
loosening mist upon the island
sealing in
the flow of light over distances
herons in green-grey waters
a girl's red hair
falling from the turret
The island itself suspended
in a primal sac of light
fed by a dark cord from within the bog

Poets send their words into the mist
in this land where symbols live—
like a dance behind a grey scrim
a promise unfulfilled
a yes or a no never said
just as the mouth begins to form the words
as the heron lifts its leg
the girl her comb

We are stamped by this
land of murmurs and half-heard chants
a dreaminess in our gaze
hands caught in mid-air
eyes following a passage of light
The young women wrap themselves in grey
 wool
and go walking
The young men watch

We remember
the dance half done
the kiss almost given
the red hair falling from the turret
hear, above grey waters
the half-promise of the lute

THE WEST'S ASLEEP

Thomas Osborne Davis (1814–1845)

When all besides a vigil keep,
The West's asleep, the West's asleep—
Alas! and well may Erin weep,
When Connaught lies in slumber deep.
There lake and plain smile fair and free,
'Mid rocks—their guardian chivalry—
Sing oh! let man learn liberty
From crashing wind and lashing sea.

That chainless wave and lovely land
Freedom and Nationhood demand—
Be sure, the great God never planned
For slumbering slaves, a home so grand.
And, long, a brave and haughty race
Honoured and sentinelled the place—
Sing oh! not even their sons' disgrace
Can quite destroy their glory's trace.

For often, in O'Connor's van,
To triumph dashed each Connaught clan—
And fleet as deer the Normans ran
Through Corlieu's Pass and Ardrahan.
And later times saw deeds as brave;
And glory guards Clanricard's grave—
Sing oh! they died their land to save,
At Aughrim's slope and Shannon's wave.

And if, when all a vigil keep,
The West's asleep, the West's asleep—
Alas! and well may Erin weep,
That Connaught lies in slumber deep.
But—hark!—some voice like thunder spake,
"The West's awake, the West's awake"—
"Sing oh! hurrah! let England quake,
We'll watch till death for Erin's sake!"

WHITE HAWTHORN IN THE WEST OF IRELAND

Eavan Boland (b.1944)

I drove west
in the season between seasons.
I left behind suburban gardens.
Lawnmowers. Small talk.

Under low skies, past splashes of coltsfoot
I assumed
the hard shyness of Atlantic light
and the superstitious aura of hawthorn.

All I wanted then was to fill my arms with
sharp flowers,
to seem, from a distance, to be part of
that ivory, downhill rush. But I knew,

I had always known
the custom was
not to touch hawthorn.
Not to bring it indoors for the sake of

the luck
such constraint would forfeit—
a child might die, perhaps, or an unexplained
fever speckle heifers. So I left it

stirring on those hills
with a fluency
only water has. And, like water, able
to redefine land. And free to seem to be—

for anglers,
and for travellers astray in
the unmarked lights of a May dusk—
the only language spoken in those parts.

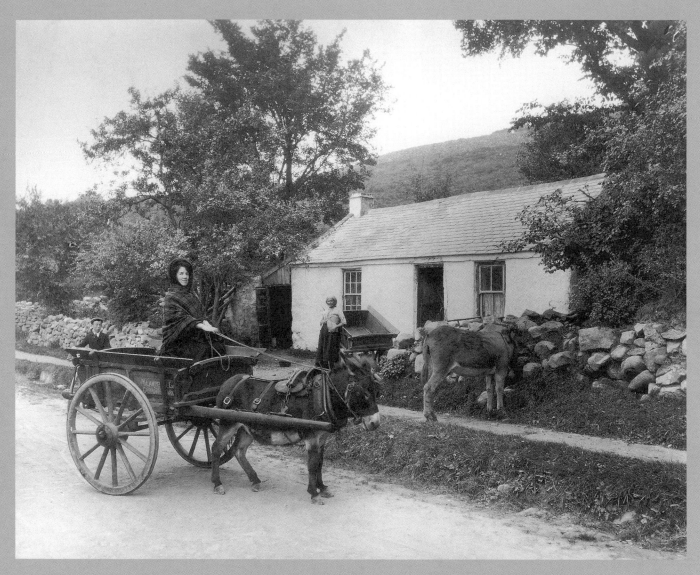

WOMAN OF THE WEST, 19TH CENTURY
(Photographer unknown)

Life in rural Ireland remained essentially
unchanged for generations, especially in
the western region, where progress and
prosperity were slow to come.

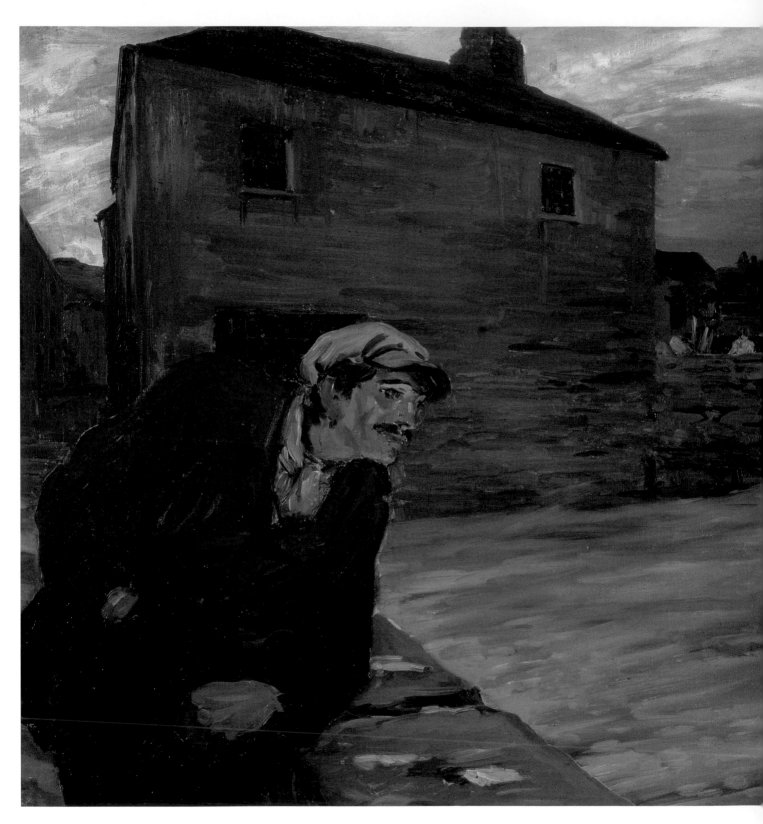

MORNING AFTER RAIN
Jack Butler Yeats (1871–1957)

Younger brother of the poet W. B. Yeats, the painter
was perhaps more at home among ordinary people,
but he was equally attracted to subjects in Irish history.

MY HEART HAS BEEN HEAVY
(from "The Rebel")

Padraic Pearse (1879–1916)

My heart has been heavy with the grief of mothers,
My eyes have been wet with the tears of children,
I have yearned with wistful old men,
And laughed or cursed with young men;
Their shame is my shame, and I have reddened for it,
Reddened for that they have gone in want, while
 others have been full,
Reddened for that they have walked in fear of
 lawyers and of their jailors
With their writs of summons and their handcuffs,
Men mean and cruel!
I could have borne stripes on my body rather than
 this shame of my people.
I say to my people that they are holy, that they are
 august, despite their chains,
That they are greater than those that hold them, and
 stronger and purer,
That they have put need of courage and to call on
 their name of their God,
God the unforgetting, the dear God that loves the
 peoples
For whom He died naked, suffering shame.
And I say to my people's masters: Beware,
Beware of the thing that is coming, beware of the
 risen people,
Who shall take what ye would not give. Did ye think
 to conquer the people,
Or that Law is stronger than life and than men's
 desire to be free?
We will try it out with you, ye that have harried and held,
Ye that have bullied and bribed, tyrants, hypocrites,
 liars!

DO YOU REMEMBER THAT NIGHT?

Anonymous (17th century)

Translated from the Irish by Eugene O'Curry

Do you remember that night
When you were at the window,
With neither hat nor gloves
Nor coat to shelter you?
I reached out my hand to you,
And you ardently grasped it,
I remained to converse with you
Until the lark began to sing.

Do you remember that night
That you and I were
At the foot of the rowan-tree,
And the night drifting snow?
Your head on my breast,
And your pipe sweetly playing?
Little thought I that night
That our love ties would loosen!

Beloved of my inmost heart,
Come some night, and soon,
When my people are at rest,
That we may talk together.
My arms shall encircle you
While I relate my sad tale,
That your soft, pleasant converse
Hath deprived me of heaven.

The fire is unraked,
The light is unextinguished,
The key is under the door,
Do you softly draw it.
My mother is asleep,
But I am wide awake;
My fortune in my hand,
I am ready to go with you.

I KNOW WHERE I'M GOING

Anonymous Street Ballad

I know where I'm going,
I know who's going with me,
I know who I love,
But the dear knows who I'll marry.

I'll have stockings of silk,
Shoes of fine green leather,
Combs to buckle my hair
And a ring for every finger.

Feather beds are soft,
Painted rooms are bonny;
But I'd leave them all
To go with my love Johnny.

Some say he's dark,
I say he's bonny,
He's the flower of them all
My handsome, coaxing Johnny.

I know where I'm going,
I know who's going with me,
I know who I love,
But the dear knows who I'll marry.

AN IRISH COURTSHIP (Linton, for *The Illustrated London News,* 1846, after a watercolor by Alfred Fripp)

Even during the worst famine years, 1845–51, Ireland was not seen clearly from London; social and economic conditions might be romanticized or condemned, depending on the point of view.

BROAGH

Seamus Heaney (b. 1939)

Riverbank, the long rigs
ending in broad docken
and a canopied pad
down to the ford.

The garden mould
bruised easily, the shower
gathering in your heelmark
was the black *O*

in *Broagh*,
its low tattoo
among the windy boortrees
and rhubarb-blades

ended almost
suddenly, like that last
gh the strangers found
difficult to manage.

THE IMPORTANCE OF ELSEWHERE

Philip Larkin (1922–1985)

Lonely in Ireland, since it was not home,
strangeness made sense. The salt rebuff of speech,
insisting so on difference, made me welcome:
once that was recognised, we were in touch.

Their draughty streets, end-on to hills, the faint
archaic smell of dockland, like a stable,
the herring-hawker's cry, dwindling, went
to prove me separate, not unworkable.

Living in England has no such excuse:
these are my customs and establishments
it would be much more serious to refuse.
Here no elsewhere underwrites my existence.

HEAD OF A YOUNG IRISHMAN
Lucian Freud (b. 1922)

Freud portrays an interesting
face, but he gives no hint of
what the young man might be
thinking.

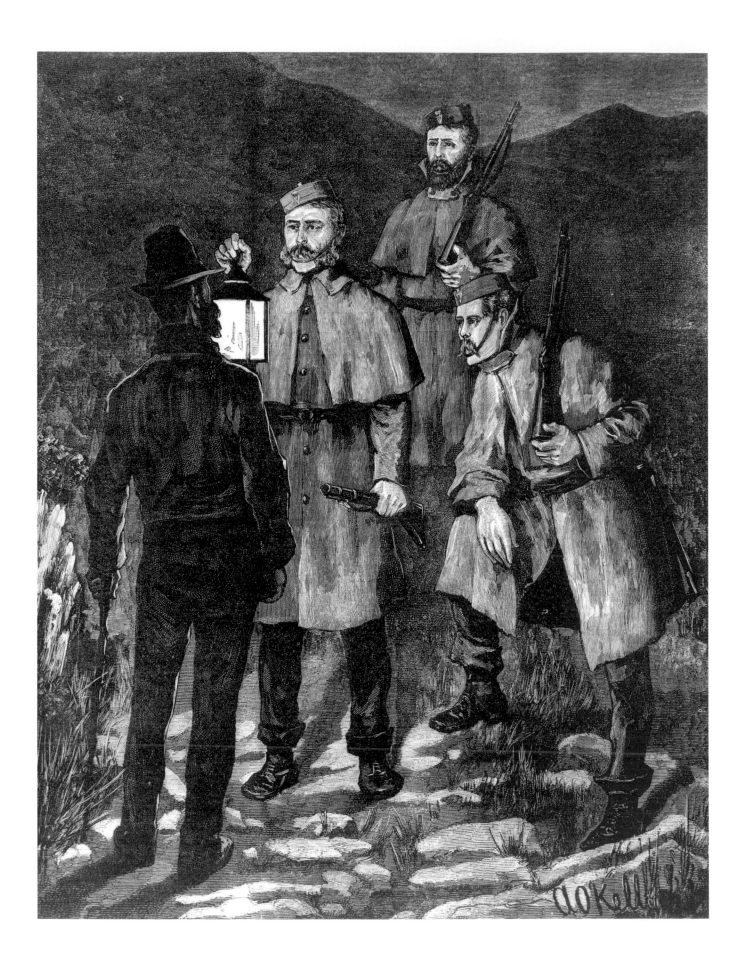

THE POLICEMAN'S LOT

(from *The Pirates of Penzance*)

Sir W. S. Gilbert (1836–1911)

When a felon's not engaged in his employment
 Or maturing his felonious little plans,
His capacity for innocent enjoyment
 Is just as great as any honest man's.
Our feelings we with difficulty smother
 When constabulary duty's to be done:
Ah, take one consideration with another,
 A policeman's lot is not a happy one!

When the enterprising burglar isn't burgling,
 When the cut-throat isn't occupied in crime,
He loves to hear the little brook a-gurgling,
 And listen to the merry village chime.
When the coster's finished jumping on his mother,
 He loves to lie a-basking in the sun:
Ah, take one consideration with another,
 The policeman's lot is not a happy one!

POLICE PATROL CHALLENGING A
SUSPECT IN IRELAND (A. O. Kelly for
The Illustrated London News, 1881)

Suspected of what? During centuries
of British rule in Ireland, a wide
variety of behavior might be looked
upon as subversive or criminal.

BELFAST GRAFFITI

Anonymous (20th century)

IRA
go away
let the little
children play

RUC
can't you see
you will be
the death of me

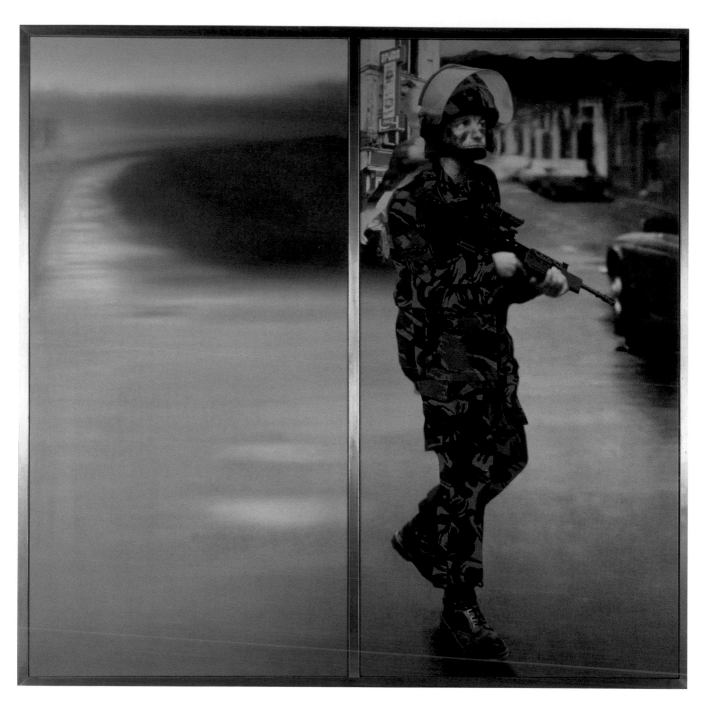

THE STATE
Richard Hamilton (b. 1922)

Hamilton portrays a patrolling soldier who represents
the authority of the British government in Northern
Ireland. For authenticity, the artist has used bits of
actual camouflage fabric in the uniform.

FROM THE FRONTIER OF WRITING

Seamus Heaney (b. 1939)

The tightness and the nilness round that space
when the car stops in the road, the troops inspect
its make and number and, as one bends his face

towards your window, you catch sight of more
on a hill beyond, eyeing with intent
down cradled guns that hold you under cover

and everything is pure interrogation
until a rifle motions and you move
with guarded unconcerned acceleration—

a little emptier, a little spent
as always by that quiver in the self,
subjugated, yes, and obedient.

So you drive on to the frontier of writing
where it happens again. The guns on tripods;
the sergeant with his on-off mike repeating

data about you, waiting for the squawk
of clearance; the marksman training down
out of the sun upon you like a hawk.

And suddenly you're through, arraigned yet freed,
as if you'd passed from behind a waterfall
on the black current of a tarmac road

past armour-plated vehicles, out between
the posted soldiers flowing and receding
like tree shadows into the polished windscreen.

IRISH POETS

Mary Ann Larkin (b. 1945)

Listen for the pounding—
hammer or hooves
or a skin-taut drum.

Somewhere past Dingle strand,
a rageful smith, blood roiling,
rocks his anvil,
beats out shapes
hot enough
for tongues to twist to sound.

A beast, winged or horned,
canters past Mullingar or Bellewstown
to lick at listening eyes,
sealed lips.

Rumors of a drum
at Clogherhead or Ardgillan,
its thunder shivers the island,
sound-shapes raining
onto tongues parched
for the wet taste of words.

The pounding
seizes the waters and the land—
the body, the blood,
the tongue shaking free,
until somewhere beyond Connemara
a woman speaks:

I was water and a sound of singing
an island rising from original seas.
And a man from Kerry
slips a message to a dead friend:
Now you can hear the pulse-music you knew well
lies beyond all poems, and before them.

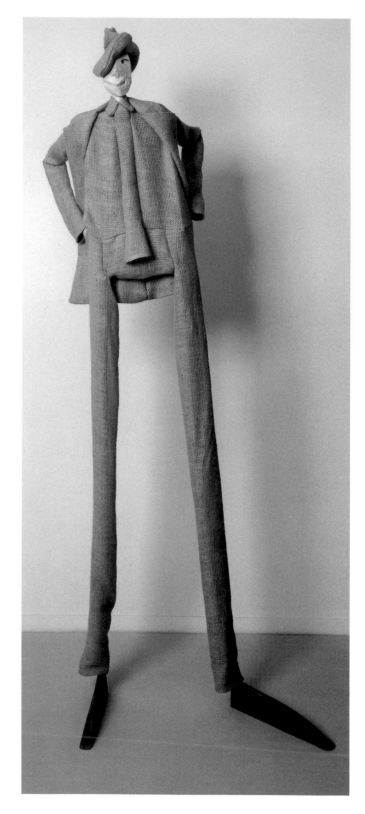

IRISH POET
William King (b. 1925)

Many poets have achieved mastery
in the English language, but some
are fluent in Irish as well.

RED HANRAHAN'S LAMENT

Charles Sullivan (b. 1933)

The fort at the edge of the cliff there,
its back to the sea, its great concentric loops of stone
imperfect now, yet strong enough to hold the place
another thousand years—it was mine for a while,
I used to own such things, but before me it was Cuiline's,
Conaing's, Ailill's—before the brave Ailill it was Aedh's,
it was Cathal's, it was Bruidge's, Máel Dúin's, all of them
Celtic kings in a small way—and before them maybe
the last resort of nameless, moonstruck tribes.

That woman who talks to the sea there,
she with the raven's hair, the widow's hooded eyes,
she'd be salty if you could taste her—she was blonde Caoilte
'til she dyed her braids, she was Deirdre when it mattered,
then flame-headed Maeve who dug Cú Chulainn's grave,
she was Ainmerech's daughter, O'Houlihan's too if she says so,
she might have been the famous Maud as well, for all I know,
later the roaring Major's wife—mine too I think, before I took to drink—
for it's me she always conjures up, you see, from wherever
I'm buried these days, waiting to be resurrected—yes,
me, Red Hanrahan, so torn by that woman's tale of grief
I'd be crying in my pint if I had one.

And you poets of the ruins now, you with the sound and light,
making noises I wouldn't know what to make of—humming
your pulse-music, is it? drumming your little drums,
strumming your poor excuses for stringed instruments—
this dum-dee-dee-dum-dee-dee-dum is driving me crazy!
Because of your kind I'm buried in the muck, my body still undone,
only my spirit free sometimes, trying to pick a fight. Don't worry,
boys and girls, I promise that I won't cross swords with you,
leaf-shaped or new. Won't start a brawl, won't chase you up the stairs
or push your ass against the wall unless I've whiskey taken.
But hear me as I try to spit this mud from my sorry mouth—
the next time I awaken we'll have words.

SHARED VALUES: ADVENTURE

POEM IN MARCH

Iain Crichton Smith (b. 1928)

Old cans sparkle. Tie slaps at the chin.
The mind puts on its sword.
This is the country of the daffodil
and the new flannels, radiant and belled.

The drawn cheeks and the spiky knees
are suddenly tulips, roses,
and England and the Low Countries.
A map of shadows passes

out on the sixteenth century sea,
Raleigh to sail and Drake
beyond the monks of eternity
reading a winter book.

SEA-FEVER

John Masefield (1876–1967)

I must go down to the seas again,
to the lonely sea and the sky,
and all I ask is a tall ship and
a star to steer her by;
and the wheel's kick and the wind's song
and the white sails shaking,
and a gray mist on the sea's face,
and a gray dawn breaking.

I must go down to the seas again,
for the call of the running tide
is a wild call and a clear call
that may not be denied;
and all I ask is a windy day with
the white clouds flying,
and the flung spray and the blown spume,
and the sea-gulls crying.

I must go down to the seas again,
to the vagrant gypsy life,
to the gull's way and the whale's way,
where the wind's like a whetted knife;
and all I ask is a merry yarn
from a laughing fellow-rover,
and quiet sleep and a sweet dream
when the long trick's over.

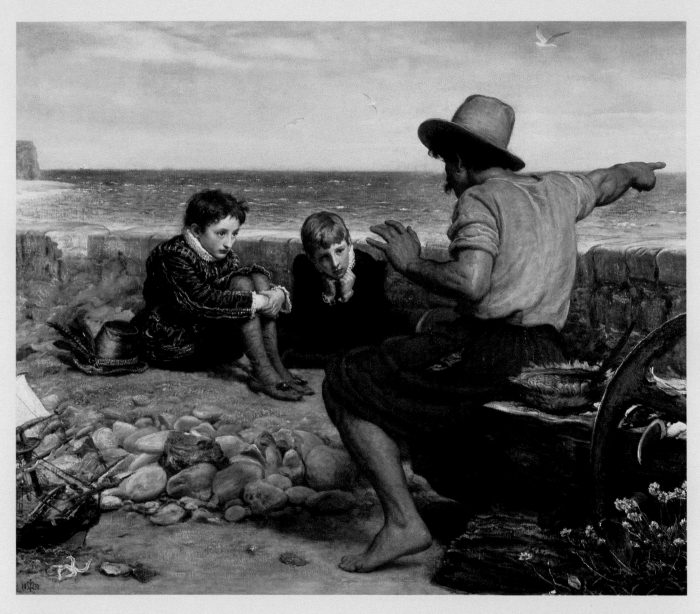

THE BOYHOOD OF RALEIGH
Sir John Everett Millais, Bt.
(1829–1896)

Sir Walter Raleigh (1552–1618)
became a celebrated navigator and
explorer, and he was for a time the
favorite of Queen Elizabeth I.
Millais's two sons served as models
for Raleigh and his brother.

BY THE DEEP SEA

(from *Childe Harold's Pilgrimage*)

George Gordon, Lord Byron (1788–1824)

There is a pleasure in the pathless woods,
There is a rapture on the lonely shore,
There is society, where none intrudes,
By the deep Sea, and music in its roar:
I love not Man the less, but Nature more,
From these our interviews, in which I steal
From all I may be, or have been before,
To mingle with the Universe, and feel
What I can ne'er express, yet can not all conceal.

Roll on, thou deep and dark blue ocean—roll!
Ten thousand fleets sweep over thee in vain;
Man marks the earth with ruin—his control
Stops with the shore;—upon the watery plain
The wrecks are all thy deed, nor doth remain
A shadow of man's ravage, save his own,
When, for a moment, like a drop of rain,
He sinks into thy depths with bubbling groan,
Without a grave, unknell'd, uncoffin'd, and unknown.

His steps are not upon thy paths, thy fields
Are not a spoil for him,—thou dost arise
And shake him from thee; the vile strength he wields
For earth's destruction thou dost all despise,
Spurning him from thy bosom to the skies,
And send'st him, shivering in thy playful spray
And howling, to his Gods, where haply lies
His petty hope in some near port or bay,
And dashest him again to earth:—there let him lay.

MARY WHEATLAND, modest teacher of swimming, heroic lifesaver, known locally as "the grace darling" of Bersted, near Bognor, Sussex (Published in *The Illustrated London News*, 1879)

Intrigued by stories in the *Bersted Parish Magazine*, a London reporter found that Mrs. Wheatland had rescued thirteen drowning swimmers from the ocean during a period of twenty years.

MR BLEANEY

Philip Larkin (1922–1985)

'This was Mr Bleaney's room. He stayed
the whole time he was at the Bodies, till
they moved him.' Flowered curtains, thin and frayed,
fall to within five inches of the sill,

whose window shows a strip of building land,
tussocky, littered. 'Mr Bleaney took
my bit of garden properly in hand.'
Bed, upright chair, sixty-watt bulb, no hook

behind the door, no room for books or bags—
'I'll take it.' So it happens that I lie
where Mr Bleaney lay, and stub my fags
on the same saucer-souvenir, and try

stuffing my ears with cotton-wool, to drown
the jabbering set he egged her on to buy.
I know his habits—what time he came down,
his preference for sauce to gravy, why

he kept on plugging at the four aways—
likewise their yearly frame: the Frinton folk
who put him up for summer holidays,
and Christmas at his sister's house in Stoke.

But if he stood and watched the frigid wind
tousling the clouds, lay on the fusty bed
telling himself that this was home, and grinned,
and shivered, without shaking off the dread

that how we live measures our own nature,
and at his age having no more to show
than one hired box should make him pretty sure
he warranted no better, I don't know.

ZOOM!

Simon Armitage (b. 1963)

It begins as a house, an end terrace
in this case
 but it will not stop there. Soon it is
an avenue
 which cambers arrogantly past the Mechanics' Institute,
turns left
 at the main road without even looking
and quickly it is
 a town with all four major clearing banks,
a daily paper
 and a football team pushing for promotion.

On it goes, oblivious of the Planning Acts,
the green belts,
 and before we know it it is out of our hands:
city, nation,
 hemisphere, universe, hammering out in all directions
until suddenly,
 mercifully, it is drawn aside through the eye
of a black hole
 and bulleted into a neighbouring galaxy, emerging
smaller and smoother
 than a billiard ball but weighing more than Saturn.

People stop me in the street, badger me
in the check-out queue
 and ask, "What is this, this that is so small
and so very smooth
 but whose mass is greater than the ringed planet?"
It's just words
 I assure them. But they will not have it.

THE WINDOW
John Quinton Pringle (1864–1925)

These poems by Larkin and Armitage
make us wonder—does Pringle's
window look outward or inward?

LEGEND

Sydney Tremayne (1912–1986)

When I grew strong to climb
over the high stone wall,
first needling through the cushat wood,
led by a cushat's call,
I reached the slope of a black hill
that wore a cloud for shawl.

I saw the sun prick through the cloud,
I heard the water run
under the roots of the long grass
that hid the chuckling stone.
I cupped some water in my hands
and raised them to the sun.

The world and both my shining hands
brightened my mouth to sing.
The little chipping birds as well
went skipping on the wing
and donkey thistles kicked their heels,
mocking the highland fling.

Never I guessed I was alone
until the sun went in
and with a whistling wind there stooped
a dark bird from the rain.
The ground rushed by me as I swung
from talons cold as chain.

So long ago, so far from here
the rainbird let me fall
I have been trudging through the world
to find that high stone wall:
restlessly turning round and round,
a beetle in a bowl.

Here is the wall, you wandering man;
never this side you'll climb.
Look, there the dandelions grow
unchanging since the game
when you were three feet low, and blew
their white heads for the time.

And there's the black bull-shouldered hill
with all its trees cut down,
but through the roots of the long grass
you'll hear the water run.
Go catch the water in your hands,
and lift them to the sun.

A LINE MADE BY WALKING
Richard Long (b. 1945)

Known for artworks based on
walking, Long created this
image by repeatedly crossing a
field along the same line, slowly
treading a visible path into the
ground, then photographing
the results. Afterward the grass
grew back.

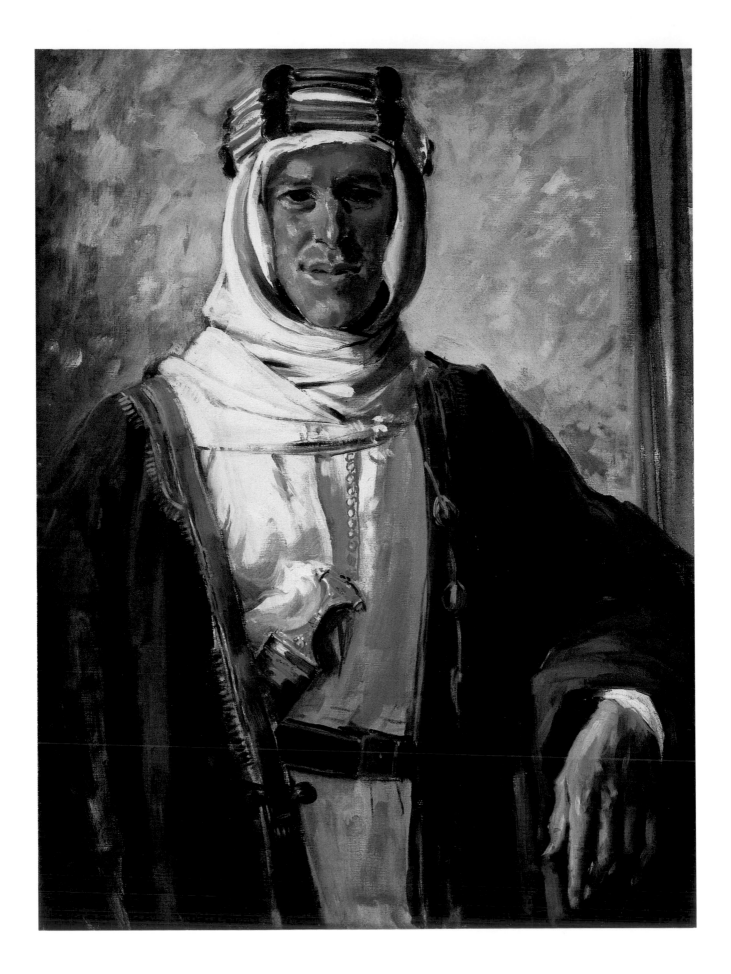

MAD DOGS AND ENGLISHMEN GO OUT IN THE MIDDAY SUN

(Song lyrics from *Words and Music*)

Noël Coward (1899–1973)

Mad dogs and Englishmen
go out in the midday sun.
The smallest Malay rabbit
deplores this foolish habit.
In Hong Kong
they strike a gong
and fire off a noonday gun,
to reprimand each inmate
who's in late.
In the mangrove swamps
where the python romps
there is peace from twelve to two.
Even caribous
lie around and snooze,
for there's nothing else to do.
In Bengal
to move at all
is seldom, if ever done,
but mad dogs and Englishmen
go out in the midday sun.

COLONEL T. E. LAWRENCE
Augustus John, OM (1878–1961)

Widely admired as "Lawrence
of Arabia," T. E. Lawrence
(1888–1935) supported the
Arab revolt against Turkish rule
while serving as a British army
officer during World War I.

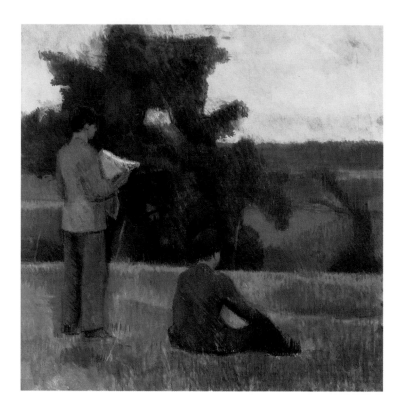

ON THE MAP
Sir William Coldstream (1908–1987)

In addition to his activity in all aspects of
the arts, Coldstream was politically com-
mitted. He studied social conditions in the
1930s, and in 1940 he enlisted in the
British army to train as a gunner, before he
was commissioned to work as a war artist.

THAT THE SCIENCE OF CARTOGRAPHY IS LIMITED

Eavan Boland (b. 1944)

—and not simply by the fact that this shading of
forest cannot show the fragrance of balsam,
the green of cypresses,
is what I wish to prove.

When you and I were first in love we drove
to the borders of Connacht
and entered a wood there.

Look down you said: this was once a famine road.

I looked down at ivy and the scutch grass
rough-cast stone had
disappeared into as you told me
in the second winter of their ordeal, in

1847, when the crop had failed twice,
Relief Committees gave
the starving Irish such roads to build.

Where they died, there the road ended

and ends still and when I take down
the map of this island, it is never so
I can say here is
the masterful, the apt rendering of

the spherical as flat, nor
an ingenious design which persuades a curve
into a plane,
but to tell myself again that

the line which says woodland and cries hunger
and gives out among sweet pine and cypress,
and finds no horizon

will not be there.

GEOGRAPHY

Sean O'Brien (b. 1952)

Tonight the blue that's flowing in
beneath the window gloves my hands
with coolness, as indifferent as a nurse.
The ridge of forest wears grey smoke
against grey pink, then deeper blue
discloses what I cannot see,
the channel's distant bays, their sands
drawn into shape by bows of surf,
then further capes and promontories,
sea-pines and isthmuses and island stepping
out from island, all
remoter than a name can reach.
Out there is home, a hammered strand
by some unvisitable sea,
beyond all empire and all sense,
enduring minus gender, case and tense,
a landfall, past imagining and free.

NOCTURNE IN BLUE AND
SILVER: CREMORNE LIGHTS
James Abbott McNeill Whistler
(1834–1903)

Although he traveled widely,
Whistler came back again and
again to the misty beauties of
the river Thames.

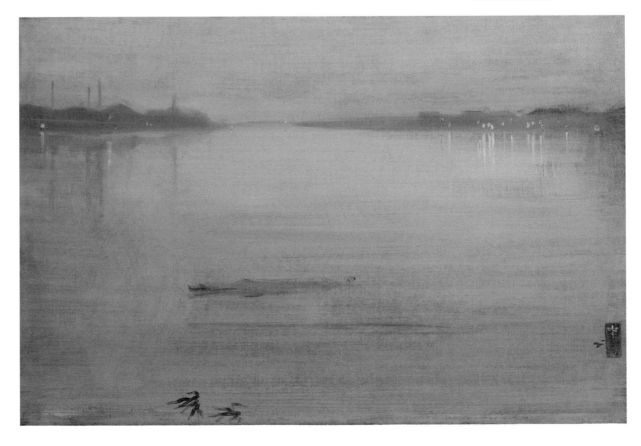

SHARED VALUES: HOME-THOUGHTS

OUT OF EXILE

John Burnside (b. 1955)

When we are driving through the border towns
we talk of houses, empty after years
of tea and conversation;
of afternoons marooned against a clock
and silences elected out of fear,
of lives endured for what we disbelieved.

We recognise the shop fronts and the names,
the rushing trees and streets into the dark;
we recognise a pattern in the sky:
blackness flapping like a broken tent,
shadow foxes running in the stars.
But what we recognise is what we bring.

Driving, early, through the border towns,
the dark stone houses clanging at our wheels,
and we invent things as they might have been:
a light switched on, some night, against the cold,
and children at the door, with bags and coats,
telling stories, laughing, coming home.

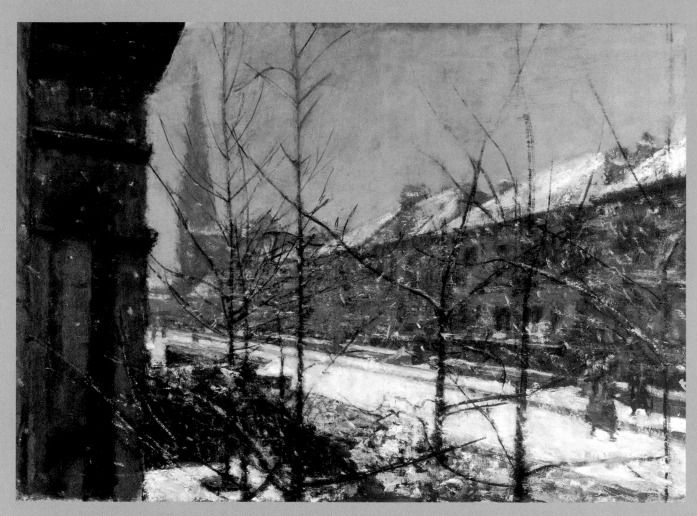

SNOW SCENE
Ruskin Spear (1911–1990)

The air is crisp, the night is clear—
wonderful to be outside, but even
better to get home!

AULD LANG SYNE

Robert Burns (1759–1796)

Should auld acquaintance be forgot,
 and never brought to min'?
Should auld acquaintance be forgot
 and days o' lang syne?

 For auld lang syne, my dear,
 for auld lang syne,
 we'll tak a cup o' kindness yet
 for auld lang syne

We twa hae rin about the braes,
 and pu'd the gowans fine;
but we've wander'd monie a weary fit
 sin' auld lang syne.

We twa hae paidl't i' the burn,
 frae mornin' sun till dine;
but seas between us braid hae roar'd
 sin' auld lang syne.

And here's a hand, my trusty fiere,
 and gie's a hand o' thine;
and we'll tak a right guid-willie waught
 for auld lang syne.

And surely ye'll be your pint-stowp,
 and surely I'll be mine;
and we'll tak a cup o' kindness yet
 for auld lang syne!

 For auld lang syne, my dear,
 for auld lang syne,
 we'll tak a cup o' kindness yet
 for auld lang syne.

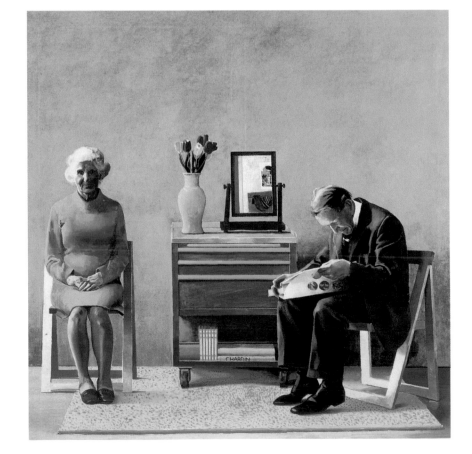

MY PARENTS
David Hockney (b. 1937)

Although bleak at first glance, this
setting is relieved by an art book
held by the father and the mirror
reflection of a postcard image: Piero
della Francesca's *Baptism of Christ,*
one of Hockney's own favorites.

HOME-THOUGHTS, FROM ABROAD

Robert Browning (1812–1889)

O to be in England
now that April's there,
and whoever wakes in England
sees, some morning, unaware,
that the lowest boughs and the brushwood sheaf
round the elm-tree bole are in tiny leaf,
while the chaffinch sings on the orchard bough
in England—now!

And after April, when May follows,
and the whitethroat builds, and all the swallows!
Hark, where my blossom'd pear-tree in the hedge
leans to the field and scatters on the clover
blossoms and dewdrops—at the bent spray's edge—
that's the wise thrush; he sings each song twice over,
lest you should think he never could recapture
the first fine careless rapture!
And though the fields look rough with hoary dew,
all will be gay when noontide wakes anew
the buttercups, the little children's dower
—far brighter than this gaudy melon-flower!

ABROAD THOUGHTS

Edward Blishen (b. 1920)

Oh, not to be in England
now that April's there!
R.B., you looked at England
through a rosy pair
of expatriate's goggles,
basking by the Med.
Imagination boggles
at the lies you spread!
You're right: the leaves are tiny;
but you quite forgot
(Italy's sunshiny)
that the rain is not!
Oh, you Apriliser!
So the thrush sings prettily!
Wise? But you were wiser,
Robert, warm in Italy!
Let your pear tree scatter
blossom on the clover:
you were in the latter
five hundred miles from Dover!

POSTCARD SCULPTURE
*Gilbert and George (b. 1942
and 1943, respectively)*

Gilbert Proesch and George
Passmore work in various
mediums, including film,
"living sculpture," and poetry.

THE CASTLE

Edwin Muir (1887–1959)

All through that summer at ease we lay,
and daily from the turret wall
we watched the mowers in the hay
and the enemy half a mile away.
They seemed no threat to us at all.

For what, we thought, had we to fear
with our arms and provender, load on load,
our towering battlements, tier on tier,
and friendly allies drawing near
on every leafy summer road.

Our gates were strong, our walls were thick,
so smooth and high, no man could win
a foothold there, no clever trick
could take us, have us dead or quick.
Only a bird could have got in.

What could they offer us for bait?
Our captain was brave and we were true. . . .
There was a little private gate,
a little wicked wicket gate.
The wizened warder let them through.

Oh, then our maze of tunneled stone
grew thin and treacherous as air.
The cause was lost without a groan,
the famous citadel overthrown,
and its secret galleries bare.

How can this shameful tale be told?
I will maintain until my death
we could do nothing, being sold;
our only enemy was gold,
and we had no arms to fight it with.

PLAINSONG

Carol Ann Duffy (b. 1955)

Stop. Along this path, in phrases of light,
trees sing their leaves. No Midas touch
has turned the wood to gold, late in the year
when you pass by, suddenly sad, straining
to remember something you're sure you knew.

Listening. The words you have for things die
in your heart, but grasses are plainsong,
patiently chanting the circles you cannot repeat
or understand. This is your homeland,
Lost One, Stranger who speaks with tears.

It is almost impossible to be here and yet
you kneel, no one's child, absolved by late sun
through the branches of a wood, distantly
the evening bell reminding you, *Home, Home,
Home,* and the stone in your palm telling the time.

THE GLEANING FIELD
Samuel Palmer (1805–1881)

Palmer idealized rural landscapes and
the figures in them—not unlike the
children who imagine castles and
warriors among the trees.

THE BRIGHTON GOODBYE

Sean O'Brien (b. 1952)

This is the place we imagine we live,
where the land slowly stops,
among streets where the sea is implied
in white walls and expectant top windows
left open for signals offshore.
The air is as bright as the harbour at noon
in the heat that can turn even cops into punters
and which we inhabit like natives of summer,
as if we had known it must come.
Now everyone seems to be leaving:
the bar-room will empty tonight
and be shuttered tomorrow,
a capsule of posters and still-sticky tables,
its music absorbed into smoke.
The girl in the shop buying fruit
has her mind on a schedule,
her brown skin important with travel.

The old have prepared for a lifetime,
and now as they sit on their doorsteps
and wait to be told or collected
they cancel the hours with freesheets
whose Gilbert and Sullivans, dogtracks
and fifteen quid bargains are clues
to a culture they've never known
time or the passion to learn.
It is suddenly late. The afternoon yawns
and continues. A lean-to of shade
in a sunken backyard is the colour
of Indian ink at the moment
the ferry swings out of the bay,
when the sea has no need to be local
and shows you the colour it keeps for itself,
which you look at with terror and love.

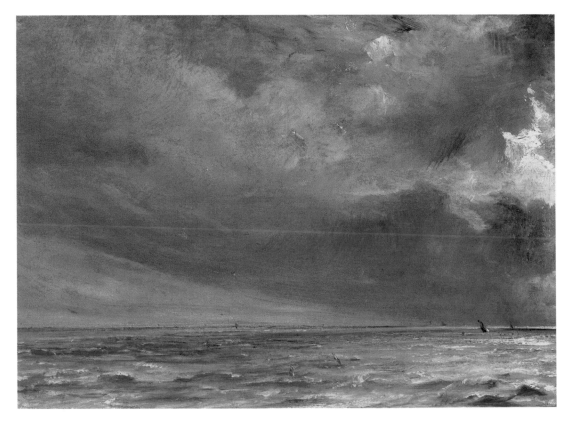

THE SEA NEAR
BRIGHTON
*John Constable
(1776–1837)*

Painted on January 1
between noon and 2 P.M.,
the artist noted, with a
"fresh breeze from S.S.W."

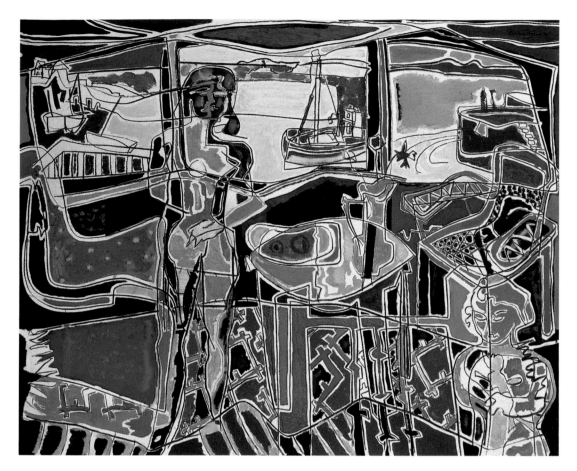

HARBOUR WINDOW
WITH TWO FIGURES,
ST. IVES; JULY 1950
Patrick Heron
(1920–1999)

Distinctly different
from traditional sea-
side paintings, Heron's
work became increas-
ingly abstract during
his long career. St. Ives,
Cornwall, remains a
center of artistic activity
in the British Isles.

WIND

Ted Hughes (1930–1998)

This house has been far out at sea all night,
The woods crashing through darkness, the booming hills,
Winds stampeding the fields under the window
Floundering black astride and blinding wet

Till day rose; then under an orange sky
The hills had new places, and wind wielded
Blade-light, luminous black and emerald,
Flexing like the lens of a mad eye.

At noon I scaled along the house-side as far as
The coal-house door. Once I looked up—
Through the brunt wind that dented the balls of my eyes
The tent of the hills drummed and strained its guy rope,

The fields quivering, the skyline a grimace,
At any second to bang and vanish with a flap:
The wind flung a magpie away and a black-
Back gull bent like an iron bar slowly. The house

Rang like some fine green goblet in the note
That any second would shatter it. Now deep
In chairs, in front of the great fire, we grip
Our hearts and cannot entertain book, thought,

Or each other. We watch the fire blazing,
And feel the roots of the house move, but sit on,
Seeing the window tremble to come in,
Hearing the stones cry out under the horizons.

SHARED VALUES: TRUTH, BEAUTY

ODE ON A GRECIAN URN

John Keats (1795–1821)

Thou still unravish'd bride of quietness,
 thou foster-child of Silence and slow Time,
sylvan historian, who canst thus express
 a flowery tale more sweetly than our rhyme:
what leaf-fringed legend haunts about thy shape
 of deities or mortals, or of both,
 in Tempe or the dales of Arcady?
 What men or gods are these? What maidens loth?
What mad pursuit? What struggle to escape?
 What pipes and timbrels? What wild ecstasy?

Heard melodies are sweet, but those unheard
 are sweeter; therefore, ye soft pipes, play on;
not to the sensual ear, but, more endear'd,
 pipe to the spirit ditties of no tone:
fair youth, beneath the trees, thou canst not leave
 thy song, nor ever can those trees be bare;
 bold Lover, never, never canst thou kiss,
though winning near the goal—yet, do not grieve;
 she cannot fade, though thou has not thy bliss,
 for ever wilt thou love, and she be fair!

Ah, happy, happy boughs! that cannot shed
 your leaves, nor ever bid the Spring adieu;
and, happy melodist, unwearièd,
 for ever piping songs for ever new;
more happy love! more happy, happy love!

for ever warm and still to be enjoyed,
 for ever panting and for ever young;
all breathing human passion far above,
 that leaves a heart high-sorrowful and cloyed,
 a burning forehead, and a parching tongue.

Who are these coming to the sacrifice?
 To what green altar, O mysterious priest,
lead'st thou that heifer lowing at the skies,
 and all her silken flanks with garlands drest?
What little town by river or sea-shore,
 or mountain-built with peaceful citadel,
 is emptied of its folk, this pious morn?
And, little town, thy streets for evermore
 will silent be; and not a soul, to tell
 why thou art desolate, can e'er return.

O Attic shape! fair attitude! with brede
 of marble men and maidens overwrought,
with forest branches and the trodden weed;
 thou, silent form! does tease us out of thought
as doth eternity. Cold Pastoral!
 When old age shall this generation waste,
 thou shalt remain, in midst of other woe
 than ours, a friend to man, to whom thou say'st,
'Beauty is truth, truth beauty,—that is all
 ye know on earth, and all ye need to know.'

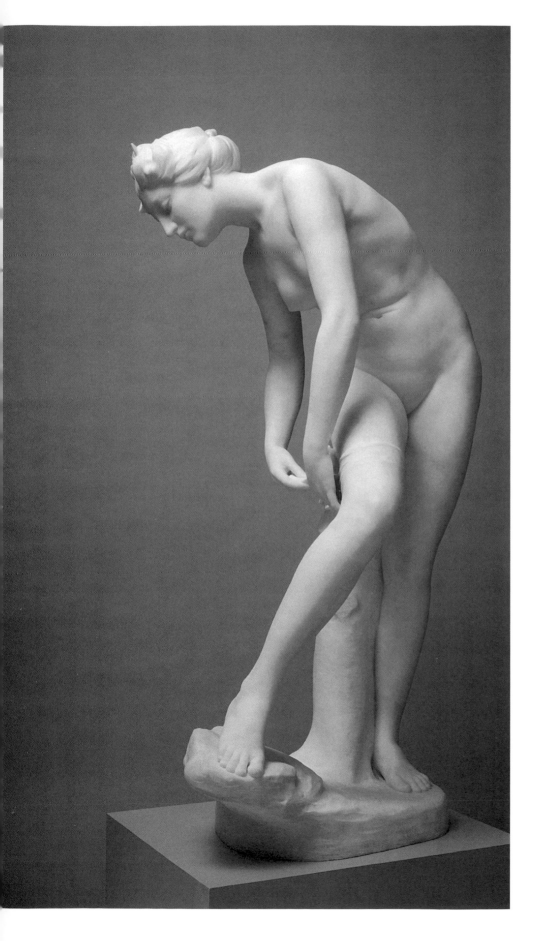

ODE ON A GRECIAN URN SUMMARIZED

Desmond Skirrow (1924–1976)

Gods chase
round vase.
What say?
What play?
Don't know.
Nice, though.

DIANA WOUNDED
Sir Bertram Mackennal (1863–1931)

The Roman goddess Diana, apparently
wounded while hunting, is shown
putting a bandage on her own leg.
This incident has no mythological
basis, but it gave the sculptor an
opportunity to demonstrate his skill.

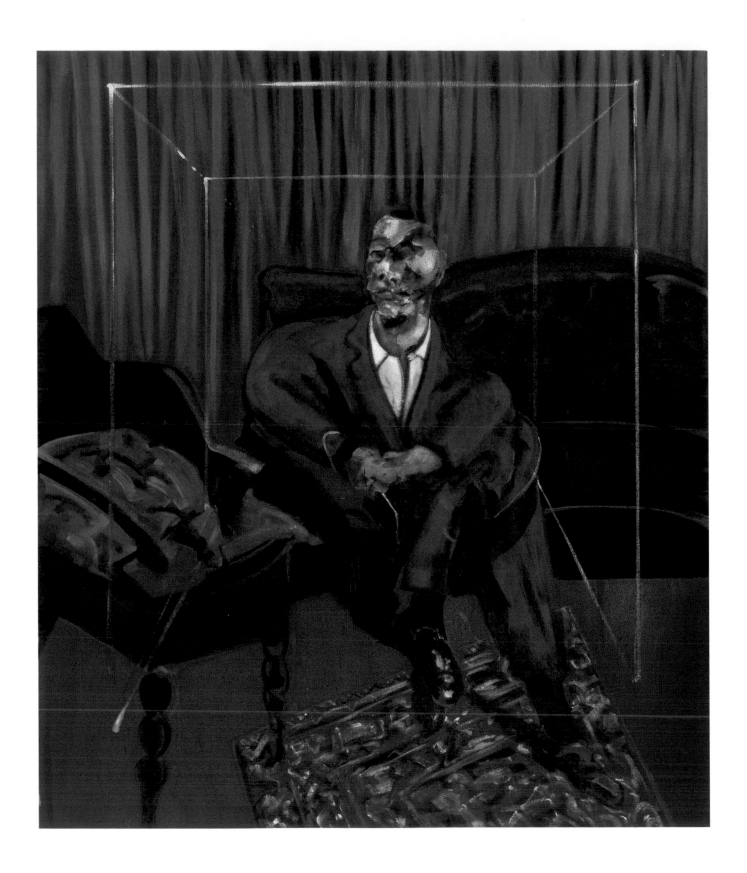

THE PROPER STUDY

(from *Essay on Man*)

Alexander Pope (1688–1744)

Know thyself, presume not God to scan;
The proper study of Mankind is Man.
Placed on this isthmus of a middle state,
A Being darkly wise, and rudely great:
With too much knowledge for the Sceptic side,
With too much weakness for the Stoic's pride,
He hangs between; in doubt to act, or rest;
In doubt to deem himself a God, or Beast;
In doubt his Mind or Body to prefer;
Born but to die, and reas'ning but to err;
Alike in ignorance, his reason such,
Whether he thinks too little or too much:
Chaos of Thought and Passion, all confused;
Still by himself abused, or disabused;
Created half to rise, and half to fall;
Great lord of all things, yet a prey to all;
Sole judge of Truth, in endless Error hurled;
The glory, jest, and riddle of the world!

SEATED FIGURE
Francis Bacon (1909–1992)

The most complex areas of this painting are in the face, where Bacon softened the outlines of the features and added sand for bulk.

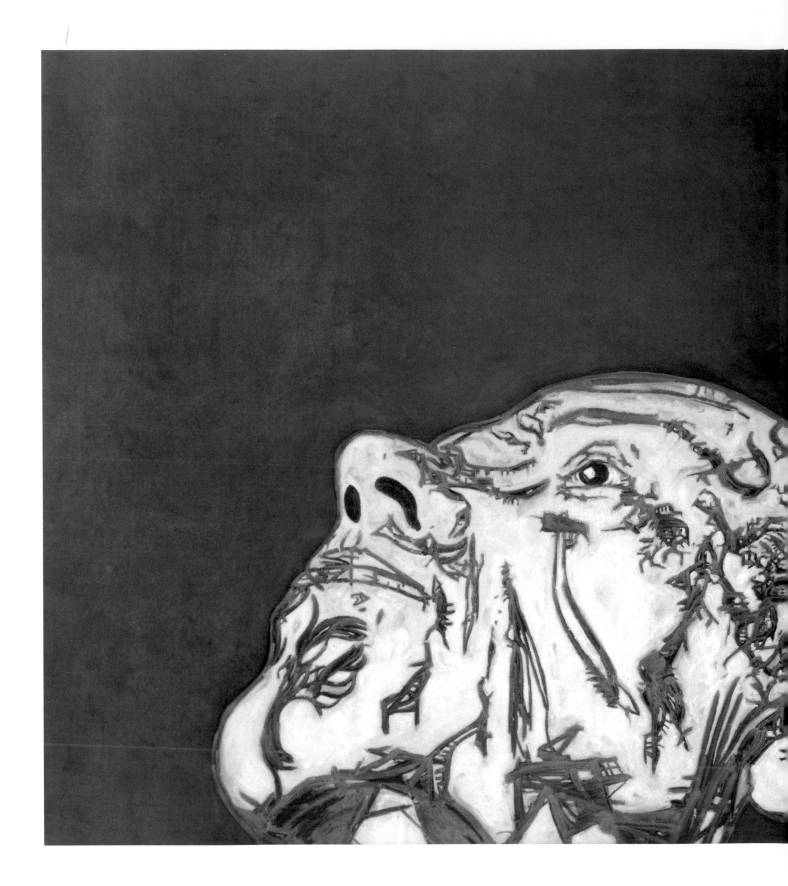

PIED BEAUTY

Gerard Manley Hopkins (1844–1889)

Glory be to God for dappled things—
 for skies of couple-colour as a brindled cow;
 for rose-moles all in stipple upon trout that swim;
fresh-firecoal chestnut-falls; finches' wings;
 landscapes plotted and pieced—fold, fallow, and plough;
 and all trades, their gear and tackle and trim.

All things counter, original, spare, strange;
 whatever is fickle, freckled (who knows how?)
 with swift, slow; sweet, sour; adazzle, dim;
he fathers-forth whose beauty is past change:
 praise him.

HEAD
Tony Bevan (b. 1951)

Hopkins, a Jesuit priest, found
beauty in all of creation.

LOVELIEST OF TREES

A. E. Housman (1859–1936)

Loveliest of trees, the cherry now
is hung with blooms along the bough,
and stands about the woodland ride
wearing white for Eastertide.

Now, of my threescore years and ten,
twenty will not come again,
and take from seventy springs a score,
it only leaves me fifty more.

And since to look at things in bloom
fifty springs are little room,
About the woodlands I will go
to see the cherry hung with snow.

CHERRY-RIPE

Robert Herrick (1591–1674)

Cherry-ripe, ripe, ripe, I cry,
full and fair ones; come and buy.
If so be you ask me where
they do grow, I answer: There
where my Julia's lips do smile;
there's the land, or cherry-isle,
whose plantations fully show
all the year where cherries grow.

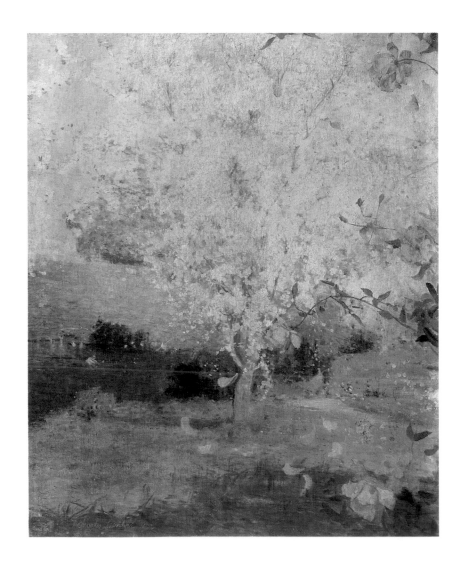

SPRINGTIME
Charles Conder (1868–1909)

Flowering cherry trees and ripening
fruit have been favorite images for
generations of poets in the British Isles.

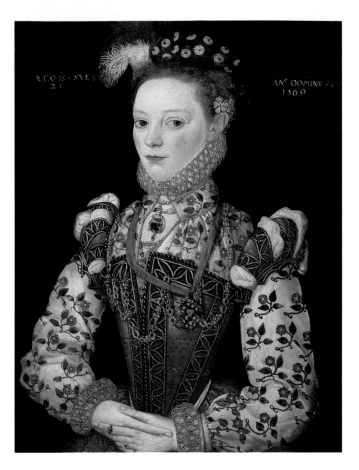

SONNET

William Shakespeare (1564–1616)

Shall I compare thee to a summer's day?
Thou art more lovely and more temperate.
Rough winds do shake the darling buds of May,
and summer's lease hath all too short a date.
Sometime too hot the eye of heaven shines,
and often is his gold complexion dimmed;
and every fair from fair sometime declines,
by chance, or nature's changing course untrimmed.
But thy eternal summer shall not fade,
nor lose possession of that fair thou owest,
nor shall death brag thou wanderest in his shade,
when in eternal lines to time thou growest.
 So long as men can breathe, or eyes can see,
 so long lives this, and this gives life to thee.

REPLY TO SHAKESPEARE

Anonymous

Compare me to a summer's day? How dare
You, sir? Suggest you know that I am hot
And humid, that I sweat unless I'm bare—
I dress this morning when I'd rather not—
Have you forgotten all you've learned about
Discretion? If you cannot hold your tongue,
I'll hold it for you, ink-stained lout!
I need no words of yours to keep me young.
My body burns with the deep fires of spring,
No matter what your calendars might say;
When I am one-and-eighty I will sing
As lustily as I could do today.
 So if you would compare me, you must choose
 A different season, or a different muse!

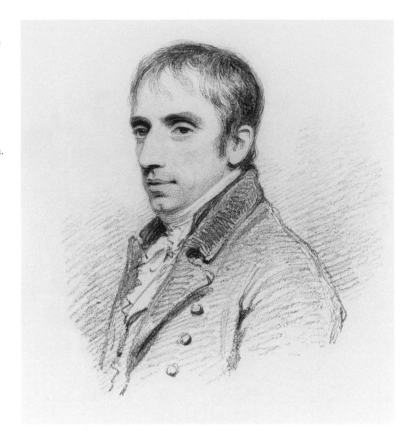

INTIMATIONS OF IMMORTALITY

(from "Ode—Intimations of Immortality from Recollections of Early Childhood," Stanzas I–V)

William Wordsworth (1770–1850)

There was a time when meadow, grove, and stream,
The earth, and every common sight,
 To me did seem
 Apparelled in celestial light,
The glory and the freshness of a dream.
It is not now as it hath been of yore;—
 Turn wheresoe'er I may,
 By night or day,
The things which I have seen I now can see no more.

 The Rainbow comes and goes,
 And lovely is the Rose,
 The Moon doth with delight
Look round her when the heavens are bare;
 Waters on a starry night
 Are beautiful and fair;

 The sunshine is a glorious birth;
 But yet I know, where'er I go,
That there hath passed away a glory from the earth.

Now, while the birds thus sing a joyous song,
 And while the young lambs bound
 As to the tabor's sound,
To me alone there came a thought of grief:
A timely utterance gave that thought relief,
 And I again am strong:
The cataracts blow their trumpets from the steep;
No more shall grief of mine the season wrong;
I hear the Echoes through the mountains throng,
The Winds come to me from the fields of sleep,
 And all the earth is gay;
 Land and sea

Give themselves up to jollity,
 And with the heart of May
Doth every Beast keep holiday;—
 Thou Child of Joy,
Shout round me, let me hear thy shouts,
thou happy Shepherd-boy!

Ye blessèd Creatures, I have heard the call
 Ye to each other make; I see
The heavens laugh with you in your jubilee;
 My heart is at your festival,
 My head hath its coronal,
The fulness of your bliss, I feel—I feel it all.
 Oh evil day! if I were sullen
 While Earth herself is adorning,
 This sweet May-morning,
 And the Children are culling
 On every side,
 In a thousand valleys far and wide,
 Fresh flowers; while the sun shines warm,
and the Babe leaps up on his Mother's arm:—
 I hear, I hear, with joy I hear!
 —But there's a Tree, of many, one,
A single Field which I have looked upon,
Both of them speak of something that is gone:
 The Pansy at my feet
 Doth the same tale repeat:
Whither is fled the visionary gleam?
Where is it now, the glory and the dream?

Our birth is but a sleep and a forgetting:
The soul that rises with us, our life's Star,
 Hath had elsewhere its setting,
 And cometh from afar:
 Not in entire forgetfulness,
 And not in utter nakedness,
But trailing clouds of glory do we come
 From God, who is our home:
Heaven lies about us in our infancy!
Shades of the prison-house begin to close
 Upon the growing Boy,
 But He
Beholds the light, and whence it flows,

He sees it in his joy;
The Youth, who daily farther from the east
 Must travel, still is Nature's Priest,
 And by the vision splendid
 Is on his way attended;
At length the Man perceives it die away,
And fade into the light of common day.

A THING OF BEAUTY

(from *Endymion*)

John Keats (1795–1821)

A thing of beauty is a joy for ever:
Its loveliness increases; it will never
Pass into nothingness; but still will keep
A bower quiet for us, and a sleep
Full of sweet dreams, and health, and quiet breathing.
Therefore, on every morrow, are we wreathing
A flowery band to bind us to the earth,
Spite of despondence, of the inhuman dearth
Of noble natures, of the gloomy days,
Of all the unhealthy and o'er-darkened ways
Made for our searching: yes, in spite of all,
Some shape of beauty moves away the pall
From our dark spirits. Such the sun, the moon,
Trees old and young, sprouting a shady boon
For simple sheep, and such are daffodils
With the green world they live in; and clear rills
That for themselves a cooling covert make
'Gainst the hot season; the mid-forest brake,
Rich with a sprinkling of fair musk-rose blooms:
And such too is the grandeur of the dooms
We have imagined for the mighty dead;
All lovely tales that we have heard or read:
An endless fountain of immortal drink,
Pouring into us from the heaven's brink.

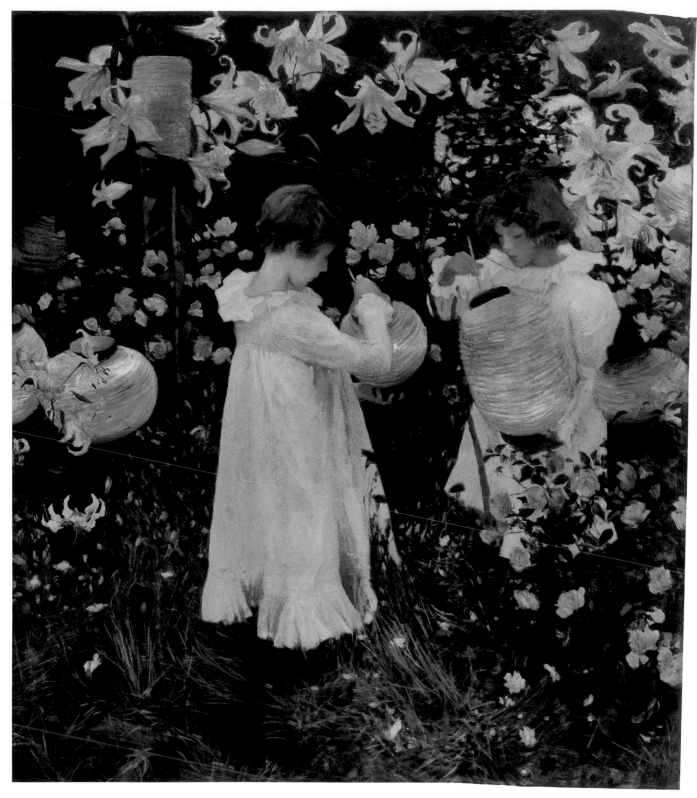

CARNATION, LILY, LILY, ROSE
John Singer Sargent (1856–1925)

Painted outdoors each day just after sunset, this picture
captures the light and the magic of early evening, as children
try to squeeze a few more moments from the grip of time.

THE GARDEN YEAR

Sara Coleridge (1802–1852)

January brings the snow,
makes our feet and fingers glow.

February brings the rain,
thaws the frozen lake again.

March brings breezes, loud and shrill
to stir the dancing daffodil.

April brings the primrose sweet,
scatters daisies at our feet.

May brings flocks of pretty lambs
skipping by their fleecy dams.

June brings tulips, lilies, roses,
fills the children's hands with posies.

Hot July brings cooling showers,
apricots, and gillyflowers.

August brings the sheaves of corn,
then the harvest home is borne.

Warm September brings the fruit;
sportsmen then begin to shoot.

Fresh October brings the pheasant;
then to gather nuts is pleasant.

Dull November brings the blast;
then the leaves are whirling fast.

Chill December brings the sleet,
blazing fire, and Christmas treat.

A GARDEN

(Written after the Civil Wars)

Andrew Marvell (1621–1678)

See how the flowers, as at parade,
under their colours stand display'd:
each regiment in order grows,
that of the tulip, pink, and rose.
But when the vigilant patrol
of stars walks round about the pole,
their leaves, that to the stalks are curl'd,
seem to their staves the ensigns furl'd.
Then in some flower's belovèd hut
each bee, as sentinel, is shut,
and sleeps so too; but if once stirr'd,
she runs you through, nor asks the word.

O thou, that dear and happy Isle,
the garden of the world erewhile,
thou Paradise of the four seas
which Heaven planted us to please,
but, to exclude the world, did guard
with wat'ry, if not flaming, sword;
what luckless apple did we taste
to make us mortal and thee waste!
Unhappy! shall we never more
that sweet militia restore,
when gardens only had their towers,
and all the garrisons were flowers;
when roses only arms might bear,
and men did rosy garlands wear?

INDEX OF ARTISTS

INDEX OF POETS

ACKNOWLEDGMENTS

Grateful acknowledgment is made for permission to reproduce the following poems and illustrations in this book. All possible care has been taken to trace ownership of every selection, and to make full acknowledgment. If any errors or omissions have occurred, they will be corrected in subsequent editions, provided that notification is sent to the publisher. (Numbers in parentheses refer to pages on which selections appear.)

POETRY

(8) Sir Stephen Spender, "I Think Continually of Those Who Were Truly Great," from his *Collected Poems 1928–1953*, Faber & Faber Ltd., London, and Random House Inc., New York. © Author's Estate. (17) "A Refusal to Mourn the Death, by Fire, of a Child in London," by Dylan Thomas, from *The Poems of Dylan Thomas*, copyright © 1945 by The Trustees for the Copyrights of Dylan Thomas, first published in *Poetry*. Reprinted by permission of New Directions Publishing Corp. and David Higham Associates Ltd., London. (19) Henry Reed, "Naming of Parts" from *Henry Reed: Collected Poems* edited by John Stallworthy (1991). © Henry Reed. Reprinted by permission of Oxford University Press. (34) Carol Ann Duffy, CBE, "Foreign," from *Selling Manhattan* by Carol Ann Duffy, Anvil Press Poetry Ltd., London, 1987. © Carol Ann Duffy. (35) John Agard, "Half-Caste," from *the new british poetry*, Paladin/Grafton Books, London. © John Agard. (54) Arthur Ransome, "71," from *Signalling from Mars: The Letters of Arthur Ransome*, Jonathan Cape, London. © Hugh Brogan and the Arthur Ransome Estate. Reprinted by permission of Christina Hardyment on behalf of the literary executors of Arthur Ransome. (56) Wynn Griffith, "There Is a Castle," from *Branwen: A Poem* by Llewelyn Wynn Griffith, J. M. Dent & Sons Ltd., London. © Author's Estate. (58) Huw Menai, "Cwm Farm near Capel Curig," from *Back in the Return* by Huw Menai, William Heinemann, Ltd., London. © Hugh Menai. Reprinted by permission of The Random House Group Limited. (61) Keidrych Rhys, "Youth," from *The Van Pool* by Keidrych Rhys, George Routledge & Co., Ltd., London. © Keidrych Rhys. (61) Tony Conran, translation from Welsh to English of Dafydd Benfras, "From Exile," in *Welsh Verse*, Poetry Wales Press, Bridgend, Wales, United Kingdom. © Tony Conran. (63) Tony Conran, translation of Evan Thomas,

"To a Noble Woman of Llanarth Hall," in *Welsh Verse*, Poetry Wales Press, Bridgend, Wales, United Kingdom. © Tony Conran. (65) David Evans, "Sona Dialect," reprinted from a periodical in *Modern Welsh Poetry*, Faber & Faber Ltd., London. © David Evans. (65) Walter Dowding, "I'r Hen Iaith A'i Chaneuon," reprinted from *Poems* by Walter Dowding, The Gomerian Press, Llandysul, Dyfed, Wales, United Kingdom, in *Modern Welsh Poetry*, Faber & Faber Ltd., London. © Walter Dowding. (66) Tony Conran, translation of anonymous poem "Attraction," in *Welsh Verse*, Poetry Wales Press, Bridgend, Wales, United Kingdom. © Tony Conran. (67) "Poem in October," by Dylan Thomas, from *The Poems of Dylan Thomas*, copyright © 1945 by The Trustees for the Copyrights of Dylan Thomas, first published in *Poetry*. Reprinted by permission of New Directions Publishing Corp. and David Higham Associates Ltd., London. (68) Ernest Rhys, "An Autobiography," as reprinted in *The Oxford Book of English Verse*, New Edition, 1939, Oxford University Press, Oxford, United Kingdom. © Ernest Rhys. (68) Tony Conran, translation of John Ceiriog Hughes, "What Passes and Endures," in *Welsh Verse*, Poetry Wales Press, Bridgend, Wales, United Kingdom. © Tony Conran. (69) Catatonia, "International Velvet" song lyrics, as published in a press release dated March 2000. © Catatonia. (70) Charles Sullivan, translation of Mary Stuart, "What Does My Life Serve?" Copyright © 2002 Charles Sullivan. All rights reserved. (81) Iain Crichton Smith, "Gaelic Songs," from his *Selected Poems*, Carcanet Press, Manchester, United Kingdom. © Iain Crichton Smith. (85) Alan Spence, "Glasgow Zen," as printed in *The Best of Scottish Poetry*, W & R Chambers Ltd., Edinburgh, Scotland, United Kingdom. © Alan Spence. (86) Tom Leonard, "Poetry," from *Intimate Voices: Selected Work 1965–1983* by Tom Leonard, reprinted in *The Faber Book of Twentieth-Century Scottish Poetry*, Faber & Faber Ltd., London. © Tom Leonard. (86) Carol Ann Duffy, CBE, "The Way My Mother Speaks," from *The Other Country* by Carol Ann Duffy, Anvil Press Poetry Ltd., London, 1990. © Carol Ann Duffy. (90) W. B. Yeats, "To a Child Dancing in the Wind," reprinted with permission from *Collected Poems* by W. B. Yeats. © 1940 by Georgie Yeats, renewed 1968 by Bertha Georgie Yeats, Michael Butler Yeats, and Anne Yeats (U. S. rights). Reprinted by permission of A. P. Watt Limited on behalf of Michael B. Yeats and Macmillan London Ltd. (world rights). (91) Mary

ILLUSTRATIONS